'*Love* shows itself more in adversity
than in prosperity; as *light* does, which
shines most where the place is darkest.'

—*Leonardo*

This book resides in the library of

DAUN THOMAS HARRIS

The Fantasia of Leonardo DA VINCI

ROSS KING

The
Fantasia
of
Leonardo
DA VINCI

His riddles, jests, fables and bestiary

Published by Levenger Press
420 South Congress Avenue
Delray Beach, Florida USA 33445
www.levengerpress.com

All text by Leonardo Da Vinci is excerpted from *The Literary Works of Leonardo da Vinci*, ed. Jean Paul Richter (London: Sampson Low, Marston, Searle & Rivington, 1883), with minor emendations where needed for clarity.

First Edition 2010

Library of Congress Cataloging-in-Publication Data

King, Ross, 1962-
 The fantasia of Leonardo da Vinci : his riddles, jests, fables and bestiary / Ross King. -- 1st ed.
 p. cm.
 Includes bibliographical references.
 ISBN 978-1-929154-41-8
 1. Leonardo, da Vinci, 1452-1519--Criticism and interpretation. 2. Leonardo, da Vinci, 1452-1519--Political and social views. I. Title.
 PQ4627.L38Z75 2010
 858'.209--dc22
 2010021593

Printed on paper from a renewable and sustainable source, using soy-blended inks
Printed in the USA

Cover and book design by Danielle Furci
Mim Harrison, Editor

For George and Linda Gibson

Contents

Fantastic Reveries
and
Exquisite Passions

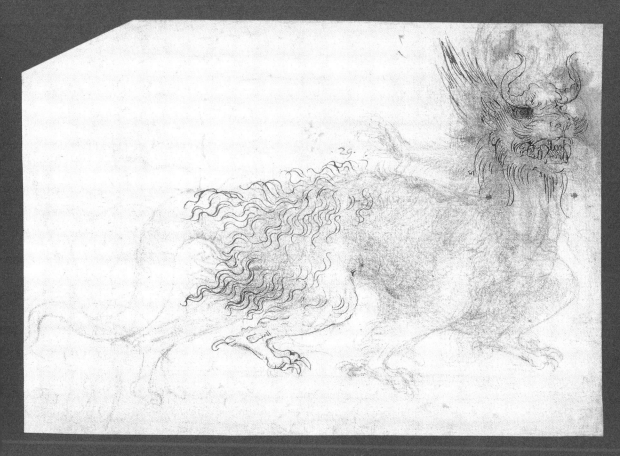

Introduction

Fantastic Reveries and Exquisite Passions

Leonardo da Vinci (1452-1519) is celebrated for a great many things. He was an inventor of genius and imagination, drawing plans for submarines, flying machines and parachutes. He was an anatomist whose understanding of heart valves was so sophisticated that leading cardiologists are today using his insights to develop new methods of cardiac surgery. And he was also, of course, the artist behind two of the world's most famous paintings, the *Last Supper* and the *Mona Lisa.*

But Leonardo as a reader and writer? He's not often given credit for his love of books. He modestly claimed he had "no power to quote from authors," admitting that "presumptuous persons" could accuse him of having no book learning. His mistress, he maintained in his defense, was experience. He studied nature, not musty books. "They who adorn themselves with the labors of others," he declared, "will not permit me my own."

Leonardo's defense of his lack of book learning is both clever and deceptive. His criticism of those who quote from others is, intriguingly, a quotation from a Latin book. "They who adorn themselves with the labors of others will not permit me my own" comes word-for-word from the *Bellum Iugurthinum* ("The Jugurthine War") by the Roman historian Sallust (86-34 BCE). Elsewhere Leonardo quotes this same work when he writes: "Nothing is to be feared so much as evil report." He was subtly letting presumptuous persons know that in

fact he *was* a man of learning—someone who could trade Latin quotes with the best of them.

Make no mistake: Leonardo was a serious reader. In about 1495 he listed the contents of his library in Milan, leaving behind a revealing record of his reading habits. It is both impressive and surprising. Altogether he listed forty works—a highly respectable inventory for the time. A decade or so later, he was able to amplify his list to 116 volumes. Among these books were ones we might expect such an inquisitive mind to acquire: Pliny the Elder's *Natural History*, a book on arithmetic, treatises on surgery, medicine and geometry, and work by the thirteenth-century scholar Albertus Magnus (whose books later graced the shelves of Victor Frankenstein). He also owned books by Aristotle, Euclid and Ptolemy.

> *In Leonardo's mind, the serious and scholarly sat side-by-side with the fanciful and poetic.*

But Leonardo's inventory encompassed works of a very wide variety. His interests clearly stretched beyond science, mathematics and medicine. He owned many religious books, such as the Bible, the Psalms, St. Augustine's *The City of God*, the writings of the fiery fifteenth-century preacher Bernardino of Siena, and *The Passion of Christ* by a Florentine priest (later a bishop) named Giuliano Dati. This latter volume he probably acquired as he began work on the *Last Supper*. A number of volumes of poetry were on his list, as were a satire on women, the fanciful travel stories of John de Mandeville, the letters of Ovid, the writings of Petrarch and romances of chivalry. Several other books on his shelves might be surprising for anyone who thinks of him merely as an artist and a scientific investigator: he owned a number of books of fables, including three different editions of Aesop.

Besides a reader, Leonardo was also a writer. He clearly had plans to print and publish books of his own. We have almost 6,000 pages of notes and

drawings in Leonardo's hand—and this amounts to less than half of the papers that he willed to his pupil Francesco Melzi. Some of these papers were obviously notes and rough drafts for books. He wrote that he hoped to produce a treatise on mechanics, another on "useful inventions," and yet another on anatomy. Some of these books undoubtedly came close to fruition. In 1517, a secretary to Cardinal Louis d'Aragon claimed to have seen in Leonardo's studio in Cloux a series of studies in anatomy, engineering and hydraulics, all composed by the master.

These were scientific works, but in Leonardo's mind, as in his personal library, the serious and scholarly sat side-by-side with the more fanciful and poetic. If his writings are any indication, he hoped to produce a book of fables, a bestiary (or "book of beasts"), and possibly even an anthology of jokes—popular books of the sort that readers devoured during the Italian Renaissance.

It is this more whimsical Leonardo who appears in this volume: a Leonardo who recites fables, poses riddles, tells jokes and makes prophecies. This is a Leonardo quite different from the one we are used to finding in accounts of his scientific pursuits or his masterly technique of painting. He is seen by most people as a daringly modern man, the rational thinker who parted the mists of superstition and foreshadowed our world. Many of his writings, however, reveal a man who was not only humorous but also bitingly satirical, surprisingly credulous, and at times (if we take him at his word) superstitious. In his bestiary he often writes not from any first-hand experience but from beliefs that have more to do with folklore and old wives' tales, or with stories handed down in medieval textbooks, than with any kind of modern scientific inquiry. This is a Leonardo who appears to believe that bats possess an "unbridled lust," that a goldfinch can cure a man of illness simply by looking at him, and that slaughtered animals whose flesh and skins are used for food and parchment retain a consciousness of what has been done to them.

It's surprising to find some of Leonardo's strange fancies bursting into what are otherwise straightforward descriptions of natural history. Take the account of

elephants in his bestiary. He begins by describing how, when the elephants cross rivers, they position themselves strategically in order to break the current. The next sentence, however, leaves the realms of zoology as we know it: "The dragon flings itself under the elephant's body, and with its tail it ties its legs; with its wings and with its arms it also clings round its ribs and cuts its throat with its teeth, and the elephant falls upon it and the dragon is burst."

One of the few experts to look seriously at this curious mishmash of the scholarly and the fantastical, Martin Kemp, argues that Leonardo's flights of imaginative fancy are not at odds with his scientific inquiries. Kemp claims that Leonardo regarded the imagination (*fantasia*) as an extension of rational thought, with the two faculties working in tandem. He even put them in the same ventricle of the brain. The way science and mythology went hand-in-hand can be seen in his account of how the human eye works. Leonardo studied vision for much of his life. He planned a treatise on optics in which he would present, he wrote, "natural and mathematical demonstrations" of how the eye worked. But his demonstrations are sometimes tinged with flights of imagination. His evidence for how "seeing rays" can be emitted by the eye is the example of the basilisk, a mythological creature that could kill, as he blandly records, with a "venomous glance."

The Leonardo who emerges from these strange fables and quaint tales is an appealing one. In them we get a glimpse of the man who loved learning of every sort, who immersed himself in books, and who elegantly and wittily entertained the courts in both Milan and France. What the nineteenth-century art critic Walter Pater said in a famous passage about the *Mona Lisa* is no less true of Leonardo. He too is full of "strange thoughts and fantastic reveries and exquisite passions."

Leonardo was born on April 15th, 1452, a few miles from the small town of Vinci, Italy, in the even smaller town of Anchiano. His birthplace is believed to have been the farmhouse of honey-colored stone that is today a museum, the Casa Natale di Leonardo da Vinci. He received a warm welcome into the world. "A grandson was born to me, the son of my son Ser Piero, on the day of April 15th, a Saturday, at the third hour of the night," his paternal grandfather proudly inscribed in a leather-bound family album. "He was named Lionardo." When the child was baptized by the local priest in the church of Santa Croce in Vinci, no fewer than five godfathers and five godmothers were on hand.

His 26-year-old father, Piero, was a notary—a professional writer of contracts, wills and other legal documents. Piero came from a long line of notaries, since his father, grandfather, great-grandfather and great-great-grandfather all worked as notaries in either Vinci or Florence. Leonardo may have been earmarked for this profession were it not for one important fact: he was born out of wedlock, which disqualified him from the profession. His mother, Caterina, was a 16-year-old peasant girl, and the difference in social standing meant she and Piero did not marry. Soon after Leonardo's birth, Caterina married

We get a glimpse of the man who loved learning of every sort, who immersed himself in books, and who elegantly and wittily entertained the courts.

a local kiln-worker and Piero another 16-year-old, Albiera degli Giovanni Amadori, who came from a well-to-do family of Florentine notaries. Leonardo remained in the house of his father. Albiera died in 1464, when Leonardo was twelve, and several years later—when he was still his father's only child—he moved to Florence, where the ambitious Piero had become a notary to the government. At the age of seventeen, he began an apprenticeship in the studio of Andrea del Verrocchio.

Verrocchio was a remarkable polymath even by the lofty standards of fifteenth-century Florence. One of Leonardo's earliest biographers, Giorgio Vasari, described Verrocchio as "at once a goldsmith, a master of perspective, a sculptor, a woodcarver, a painter, and a musician." One of his most famous works, done for the ruling Medici family in the 1470s, was a bronze *David*. Standing just over four feet high, Verrocchio's David is far from the stern, muscular colossus that Michelangelo would unveil in Florence three decades later. He is a slim, curly-haired youth who stands with his left hand on his hip and his right hand holding the small sword with which he has decapitated Goliath. His most distinguishing feature is the half-smile that plays on his lips. Art historians have long conjectured that Verrocchio's model for his David was Leonardo, his young apprentice at the time. If so, this is our first glimpse of Leonardo—a handsome, athletic youth with a head of tousled curls and a knowing smile.

It is easy to imagine the young Leonardo with a mischievous smile. He is known to have used his extraordinary artistic abilities to perpetrate several memorable pranks. In one of them, related by Vasari, his father gave him a wooden buckler—a small shield—to decorate for a local peasant. Leonardo assembled in his room a grisly collection of dead lizards, crickets, snakes, locusts, bats and other creatures, from which he created "a fearsome and horrible monster." As the pile of reptiles and insects rotted and stank, he meticulously painted his monster on the shield, depicting it emerging from a cave and belching venom. When it was finished, he darkened his room and summoned his father. At first his father was terrified by the sight of the fire-breathing monster—but ultimately he was impressed by his son's amazing artistry.

Another trick, carried out during Leonardo's short stay in Rome, likewise involved a frightening monster. According to Vasari, one day the gardener at the Vatican found an odd-looking lizard for which Leonardo fashioned a pair of wings made from the skins of other reptiles. He then added horns and a beard, kept the creature in a box in his studio, and showed it to friends to "frighten the

life out of them." Visitors to Leonardo's studio needed to be wary indeed. He was also known for scaring them by inflating sheep intestines with a bellows so they filled the entire room, forcing his guests to crowd into a corner. "He perpetrated hundreds of follies of this kind," reported Vasari.

Leonardo's fascination with monsters and lizards indicates how he loved the unusual, the grotesque, the fantastical, the out-of-all-proportion. One of the books in his library was the Florentine poet Luigi Pulci's *Morgante Maggiore*. Published in 1483, the poem was an epic about a giant who becomes the sidekick of Orlando, one of Charlemagne's knights. Leonardo seems to have been strangely fascinated by giants. One of the pages in the Codex Atlanticus—a collection that contains Leonardo's studies in anatomy, astronomy, botany and mathematics— graphically describes the emergence from the Libyan desert of a giant with a "terrible face." This gargantuan creature is described elsewhere in his notes as having "swollen and bloodshot eyes ... the nose is arched upwards with gaping nostrils from which protrude many thick bristles. Below this is the arched mouth with gross lips from the extremity of which there were whiskers like those of cats."

> *Leonardo's fascination with monsters and lizards indicates how he loved the unusual, the grotesque, the fantastical, the out-of-all-proportion.*

For someone interested in proportion and the "golden ratio," Leonardo thoroughly enjoyed the disproportionate and the downright hideous. His drawings of cartoonishly ugly men and women are well known. Vasari claims that if Leonardo saw "a man of striking appearance, with a strange head of hair or beard," he would follow him through the streets all day long, fixing his grotesque image in his mind. He likewise delighted in sketching bizarre-looking malformations. Gian Paolo Lomazzo, in his *Treatise on Painting* (1584), described

how he saw in the possession of a sculptor named Francesco Borella a drawing Leonardo made of a curious creature: a "beautiful youth" with "the penis on the forehead and without the nose, another face being on the back of the head, with the penis below the chin and with the ears attached to the testicles; this two-heads-in-one had faun's ears."

This sketch has not survived, but the Royal Library at Windsor has several of Leonardo's magnificent drawings of dragons. These may have been created as designs for costumes at pageants or festivals at court. After he left Florence for Milan in 1482, he worked for Lodovico Sforza as, among other things, a theatrical set designer. His first biographer, Paolo Giovio, claimed he was "a rare and masterful inventor of every fine and novel thing in delectable theatrical spectacles." He once designed the stage set for a pageant in which a mountain would open to reveal Pluto and his devils in their cavernous paradise. "When Pluto's paradise is opened," Leonardo wrote of his special effects, "then there will be devils, who play on pots to make infernal noises. Here will be death, the furies, Cerberus, many cherubs who weep. Here fires will be made of various colors." Fire-breathing monsters emerging from lairs were never far from Leonardo's imagination. He reveled in their creation, seeing them as proof of an artist's powers of fantasy and invention. "If the painter wishes to form images of animals or devils," he wrote in one of his notebooks, "with what abundance of invention his mind teems."

Leonardo's mind teemed with invention throughout his life. In what may have been his last work, Leonardo did a (now lost) painting for King Francis I of a dragon fighting a lion. He made no apologies for depicting imaginary creatures, claiming that the painter's works were "more infinite than those made by nature," and that he could produce things that "nature never created." He took these creations very seriously, since his notebooks provide advice about how an artist might compose a dragon: he should take the head of a mastiff, the eyes of a cat, the ears of a porcupine, the nose of a greyhound, the brow of a lion and the neck of a tortoise.

This detailed description shows us Leonardo's combination of rational observation and imaginative flight, as his *fantasia* is given a sound footing in the scrutiny of nature and an attention to detail. He would surely have agreed with the Spanish painter Francisco de Goya (who created monsters of his own) that the two faculties must always work together. As Goya wrote: "Fantasy, abandoned by reason, produces impossible monsters; united with it, she is the mother of the arts and the origin of marvels."

Leonardo pokes fun at human foibles in his fables and riddles. But besides fantasy and laughter, there is another, more serious strain in his writings. He often betrays a good deal of pessimism and rage. The targets of his exasperated anger are age-old ones: war, cruelty, greed, deceit. At times his fables—and, even more, his doom-laden riddles, or "prophecies"—remind us of Beethoven's despairing cry: "Oh, may the whole miserable rabble of humanity be cursed and damned."

As a lone voice crying out against the self-destructive follies of humanity, Leonardo comes across as exceptionally modern. Despite the pranks, laughter and artistic beauties, the Italian Renaissance was witness to much cruelty and violence. Leonardo experienced the two French invasions of Italy in the 1490s, and for a time he worked as the chief military engineer for the fierce and treacherous Cesare Borgia. The turbulent affairs of Italy at this time led Leonardo's fellow Florentine Niccolò Machiavelli to take a bleak measure of humanity: "One can make this generalization about men," he wrote in *The Prince*. "They are ungrateful, fickle, liars and deceivers, they shun danger and are greedy for profit."

Leonardo may not have been quite so pessimistic, but in his writings he deplores man's inhumanity. Again and again, he bewails the despoiling of the countryside, in particular trees. Most prevalent of all is his sincere outrage at man's ill treatment of animals. Whipping beasts of burden, slaughtering lambs and kids, even using animals' skins for parchment: Leonardo regards all these practices as unnecessarily cruel. Yet he is no misty-eyed romantic about nature, since his fables show the animal world (and the bird world) to be red in tooth and claw. Both his fables and his bestiary reveal a survival-of-the-fittest contest in the natural world where children destroy parents and even the trees contend against one another.

As a lone voice crying out against the self-destructive follies of humanity, Leonardo comes across as exceptionally modern.

If our first glimpse of Leonardo is the smiling youth in Verrocchio's *David*, our last is the famous self-portrait done in about 1513. Now in the Biblioteca Reale in Turin, this red-chalk drawing appears to depict an old man, though at the time Leonardo was actually only about sixty. He has shoulder-length hair and the wavy, elongated beard of a biblical prophet or ancient philosopher. The face is lined, the eyebrows bushy, the mouth downturned, the deep-set eyes mournful and serious. There is little laughter or levity here. Machiavelli (who also enjoyed a joke) once wrote of himself:

> *"If at times I laugh or sing*
> *I do so because I have no other way than this*
> *To give vent to my bitter tears."*

Looking at the Turin self-portrait, it's easy to imagine Leonardo likewise using his stories and jests to disguise an unease about the state of the world.

Emblems and Caprice

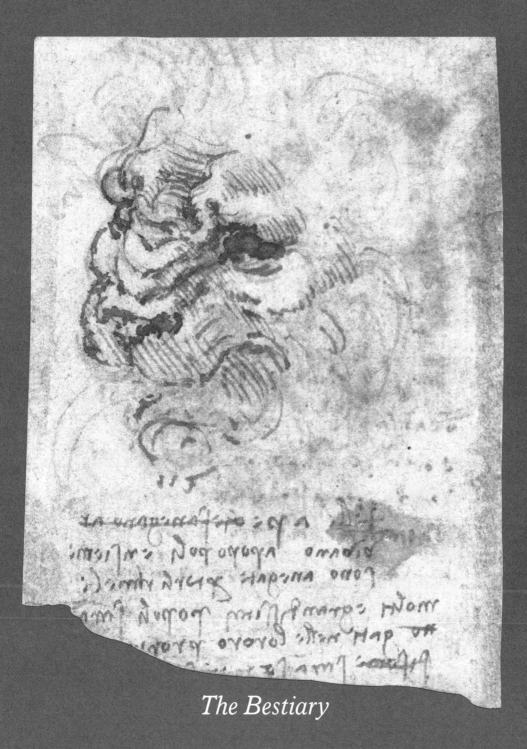

The Bestiary

Emblems and Caprice

eonardo's interest in birds and animals is well known. According to Vasari, the whole of the animal kingdom gave him pleasure, and he treated all creatures "with wonderful love and patience." Vasari goes on to tell the appealing story of how Leonardo would purchase caged birds only to release them into the air. He even seems to have been, for at least part of his life, a vegetarian, since one of his contemporaries reported (in amazed admiration) how he neither fed on anything that contained blood nor permitted "any injury to be done to any living thing."

Leonardo's first memory was of birds. A strange passage in the Codex Atlanticus records how, while he was in his cradle, a hawk "came down to me, opened my mouth with its tail, and struck me many times with its tail within my lips." The upshot of this experience was that he was "always destined to be deeply concerned with the hawk." He was deeply concerned insofar as he was obsessed with the miracle of flight, and he spent much time studying birds. His notebooks record his fascinated scrutiny of a "bird of prey which I saw as I was going to Resole, above the place of the Barbiga in 1505, on the fourteenth day of March." Not coincidentally, 1505 was the year that Leonardo wrote his treatise on the flight of birds.

Leonardo's interest in the animal kingdom was first and foremost scientific. He dissected monkeys, oxen, horses and pigs, and he once cut open the leg and

foot of a bear. He was interested in the nuts and bolts of how birds and animals were put together. He once wrote himself a memo: "Describe the tongue of the woodpecker and the jaw of the crocodile." Fierce creatures fascinated him. He seems to have spent much time studying the captive lions in their enclosure behind the Palazzo Vecchio in Florence. "I once saw a lamb being licked by a lion in our city of Florence," he writes. The biblical metaphor soon disappears, however, since he reports that the lion ate the lamb.

Leonardo also took a more capricious interest in birds and animals. One of the books he owned was a 1474 Venetian edition of the *Fior di Virtù* ("Flower of Virtue"). This was a bestiary, or "book of beasts," that combined legends of birds and animals with descriptions of virtues and vices. Written in the early fourteenth century, the *Fior di Virtù* became one of the most popular and widely read books in Italy. It was often used to teach children to read. (It was presumably aimed only at boys: one passage claimed that teaching girls to read would "multiply evil with evil.") Leonardo himself probably first learned to read with the help of the *Fior di Virtù*—which meant that from a young age he would have read charming, moralistic stories featuring foxes, ravens, moles and hares, as well as heard about fabulous creatures such as mermaids.

He also owned a copy of another equally famous Italian bestiary, Cecco d'Ascoli's *L'Acerba*. Cecco composed this work, a pseudo-scientific poem, in the 1320s, around the time that the *Fior di Virtù* was written. A professor of astrology at the university in Bologna, Cecco offered his readers a smorgasbord of astronomy, morality, mineralogy, theology and anatomy. He even wrote about the circulation of the blood. He was deeply proud of his scientific approach, which he contrasted to the *fantasia* of Dante's poetry. "Here there is no frog-like song," he declares of *L'Acerba*, "no singing in the manner of a poet who invents, picturing useless trifles in his imagination. Here, on the contrary, all natural truths shine out, gladdening the minds of those who understand."

If Cecco's "natural truths" would have appealed to Leonardo, so did the poem's quirkier sections. The third part of *L'Acerba* included descriptions of

animals, the material for which Cecco borrowed from earlier bestiaries and encyclopedias. His devotion to natural truths did not prevent him from recording the habits of creatures such as dragons and basilisks, the latter of which could be killed, he claimed, by weasels armed with rue. He was burned at the stake as a heretic in Florence in 1327, not because of *L'Acerba* but for having taught his students (as one chronicler wrote) "idle things" that were "contrary to the Faith." *L'Acerba* went on to be reproduced in at least forty manuscripts and then printed in 1476.

Bestiaries served an important moral and religious function. The inspiration for them was found in the Bible. The Book of Job describes how, after his wealth was gone, his children killed and his body ravaged by disease, Job still maintained his belief and trust in God. Asked by a friend how it was possible to understand a God who was beyond all human reasoning, he replied: "But ask now the beasts, and they shall teach thee; and the fowls of the air, and they shall tell thee. Or speak to the earth and it shall teach thee, and the fishes of the sea shall declare unto thee. Who knoweth not in all these that the hand of the Lord hath wrought this?"

From a young age he would have read charming, moralistic stories featuring foxes, ravens, moles and hares.

Birds, animals, plants, fish: all revealed God's workmanship. And if birds and animals were the handiwork of God, then they provided both useful examples for moral conduct and succinct illustrations of Christian dogma. Animal behavior could be studied, that is, in order to understand Biblical teachings and God's plan for the world.

Medieval bestiaries like the *Fior di Virtù* and *L'Acerba* offered a selection of creatures, both real and imagined, that could be used as vehicles for moral and religious teaching. The ascribed behavior—such as the weasel giving birth

through her ears—was usually hilariously unsound. But throughout the Middle Ages these moral encyclopedias, with their troves of animal lore, were among the most popular books in Europe.

Sometime in the early 1490s, Leonardo began writing out descriptions of animals in a pocket notebook now in the Institut de France in Paris. Altogether he described more than eighty birds, animals, reptiles and insects. The traits and behavior he attributes to some may be the result of his actual observations. His fascination with birds of prey mean his comments about the eagle—that it always leaves some of its prey for other birds—could be based on careful scrutiny of its habits. Likewise his comment that the falcon "has been seen to assault the eagle, the queen of birds." We can imagine Leonardo on the hills outside Florence, shading his eyes as he studies this fierce aerial combat.

Leonardo's description of the wolf, which chews off its foot to escape a trap, could also come from what he saw with his own eyes. His comments on imprisoned lions sometimes refusing to eat lambs are almost certainly inspired by time spent looking into the lion enclosure behind the Palazzo Vecchio, since these lions, as we know from Leonardo's other observations, enjoyed a diet of lamb.

Yet Leonardo brings more than just personal observations to his bestiary. Another of his statements about lions—that they are afraid of "the noise of empty carts, and likewise the crowing of cocks"—might appear to come from his familiarity with the lion enclosure. It's easy to imagine Leonardo standing behind the Palazzo Vecchio at dawn, watching the lions startled by crowing roosters and the trundling of handcarts along cobbled alleyways. In fact, his description comes almost word-for-word from Pliny the Elder's *Natural History*. Likewise, though his description of the eagle begins with observable fact about its prey, he cannot resist repeating a common legend: "The eagle when it is old flies so high that it

scorches its feathers," he writes, "and Nature allowing that it should renew its youth, it falls into shallow water." This is a repetition of the myth (derived from both the Psalms and the story of Icarus) that the eagle can renew its youth by flying into the sun, burning off its old feathers, and then plunging into rejuvenating waters. It is not a spectacle Leonardo is likely to have witnessed.

Most of Leonardo's bestiary is not actually the fruit of personal observation or scientific study. More often, his remarks closely follow earlier writers. His description of the kite is typical. "We read of the kite that, when it sees its young ones growing too big in the nest, out of envy it pecks their sides, and keeps them without food." This could easily have been something Leonardo witnessed for himself. His first memory, after all, was of a kite. As he admits, however, this behavior is something he has read about. Isidore of Seville, a seventh-century Spanish bishop, described the hawk in exactly this way. "Hawks are cruel to their young," he wrote in his *Etymologies*. "When they see that the chicks are able to fly they stop giving them food, hit them with their wings, drive them from the nest and make them hunt while infants."

It's easy to imagine Leonardo standing behind the Palazzo Vecchio at dawn, watching the lions and the trundling of handcarts along cobbled alleyways.

There is a surprising lack of skepticism here. Leonardo generally does not scruple to repeat uncritically the legends found in medieval bestiaries and other books. The folklore that the swan sings before it dies, repeated in most bestiaries, can be traced back to Aesop. Pliny the Elder declared the story to be false, but Leonardo blithely repeats it. The same with crocodiles. He takes from Cecco d'Ascoli and Sir John de Mandeville (both of whose books were on his shelves) the myth that the crocodile weeps after eating a man. From Cecco he

freely borrows descriptions of the beaver, the oyster, the caterpillar and the spider. His comments about toads eating earth, as well as his account of how songbirds avert their gaze from dying patients, are found in the *Fior di Virtù*. From Pliny he takes an entire menagerie of beasts: the elephant, the lion, the tiger, the ichneumon, the catoblepas, the hippopotamus, and serpents such as the cerastes, the amphisboena, the iaculus, the boa and the asp.

Leonardo not only discusses exotic creatures he is unlikely ever to have seen, such as the crocodile or hippopotamus; he also describes numerous mythical animals. The basilisk, the phoenix, the unicorn, the mermaid, the lumerpa (a bird from Asia Minor that, according to Leonardo, "shines so brightly that it absorbs its own shadow")—these fabulous creatures appear side-by-side with wolves, eagles and lambs. They were staples of medieval bestiaries, and some, such as the phoenix, went back to antiquity. Herodotus, for example, described the phoenix in the fifth century BCE. For medieval bestiarists, these creatures could easily be given a Christian gloss. The twelfth-century *Aberdeen Bestiary* related how the phoenix, rising from the flames, symbolized the resurrection of the righteous. Similarly, the unicorn (which appears in the King James Version of the Bible) was always a figure for Christ. The motif of a lady with a unicorn was an analogy for Christ and the Virgin Mary.

Leonardo makes some of his beasts emblems for specific virtues or vices: the hoopoe as gratitude, the bear as rage, and so forth. Others, such as the hippopotamus and the chameleon, lack any symbolic content. The creatures lacking moral labels are taken largely from Pliny the Elder's *Natural History*, while those given explicit morals come largely from traditional bestiaries such as the *Fior di Virtù* and Cecco d'Ascoli's *L'Acerba*. Crucially, however, Leonardo often omits the usual Christian gloss provided by previous bestiarists. His unicorn merely becomes a symbol of sexual desire (because legend says it cannot resist the charms of a maiden). Likewise, the phoenix represents not the resurrection of the righteous but the virtue of constancy.

Leonardo treats the real animals in his bestiary in exactly the same way. He

writes that the beaver, hunted for its "medicinal testicles"—that is, the extract known as castoreum—escapes its pursuers by biting off its testicles and leaving them behind. This behavior is described by Pliny the Elder, and *L'Acerba* and the *Fior di Virtù*, like most bestiaries, happily repeat it. Most writers saw a Christian analogy in the beaver's self-castration: the good Christian casts off his vices to escape the devil, who then loses interest. But Leonardo provides no such analogy. The beaver is for him simply a symbol of peace.

An even more striking omission is found in his description of the pelican. Leonardo claims, like many writers before him, that this bird revives its dead chicks by piercing its breast and bathing them in blood until they return to life. This legend has obvious Christian overtones, since the pelican, like Christ, sheds its blood to give life to others. St. Thomas Aquinas, in the hymn "Adoro Te Devote," uses the analogy when he appeals to Christ: "O loving Pelican! O Jesus Lord! Unclean I am, but cleanse me in Thy Blood!" But no comparison to Christ appears in Leonardo's account of the pelican. Intriguingly, nor does any skepticism regarding the pelican's resuscitation of its young—even though Isidore of Seville, many centuries earlier, expressed his doubts.

If Leonardo was a student of books rather than of nature when it came to his bestiary, it's worth reminding ourselves of his great skill in depicting animals in his art—a skill based on astute observation and dazzling artistic talent. He repeats conventional lore in his bestiary when he writes that the ermine (a Christian symbol of purity) will let itself be taken by hunters rather than get its coat soiled by hiding in a dirty hole. But when he comes to paint the animal in *Lady with an Ermine*, he creates a wholly original and mesmerizingly brilliant creature. As the Leonardo scholar Kenneth Clark has observed: "The modelling of its head is a miracle; we can feel the structure of the skull, the quality of the skin, the lie of the fur. No one but Leonardo could have conveyed its stoatish character, sleek, predatory, alert, yet with a kind of heraldic dignity."

We might not get in print from Leonardo what we get from him in paint. But there are few writers, after all, who could hope to match Leonardo's brush.

Leonardo's Bestiary

Virtue

THE GOLD-FINCH is a bird of which it is related that, when it is carried into the presence of a sick person, if the sick man is going to die, the bird turns away its head and never looks at him; but if the sick man is to be saved the bird never loses sight of him but is the cause of curing him of all his sickness.

Like unto this is the love of virtue. It never looks at any vile or base thing, but rather clings always to pure and virtuous things and takes up its abode in a noble heart; as the birds do in green woods on flowery branches. And this Love shows itself more in adversity than in prosperity; as light does, which shines most where the place is darkest.

Cheerfulness

Cheerfulness is proper to THE COCK, which rejoices over every little thing, and crows with varied and lively movements.

Sadness

Sadness resembles THE RAVEN, which, when it sees its young ones born white, departs in great grief, and abandons them with doleful lamentations, and does not feed them until it sees in them some few black feathers.

Rage

It is said of THE BEAR that when it goes to the haunts of bees to take their honey, the bees having begun to sting him he leaves the honey and rushes to revenge himself. And as he seeks to be revenged on all those that sting him, he is revenged on none; in such wise that his rage is turned to madness, and he flings himself on the ground, vainly exasperating, by his hands and feet, the foes against which he is defending himself.

Gratitude

The virtue of gratitude is said to be more developed in the birds called HOOPOES which, knowing the benefits of life and food they have received from their father and their mother, when they see them grow old, make a nest for them and brood over them and feed them, and with their beaks pull out their old and shabby feathers; and then, with a certain herb restore their sight so that they return to a prosperous state.

Avarice

THE TOAD feeds on earth and always remains lean—because it never eats enough:—it is so afraid lest it should want for earth.

Ingratitude

PIGEONS are a symbol of ingratitude; for when they are old enough no longer to need to be fed, they begin to fight with their father, and this struggle does not end until the young one drives the father out and takes the hen and makes her his own.

Generosity

It is said of THE EAGLE that it is never so hungry but that it will leave a part of its prey for the birds that are round it, which, being unable to provide their own food, are necessarily dependent on the eagle, since it is thus that they obtain food.

Discipline

When THE WOLF goes cunningly round some stable of cattle, and by accident puts his foot in a trap, so that he makes a noise, he bites his foot off to punish himself for his folly.

Flatterers

THE SIREN sings so sweetly that she lulls the mariners to sleep; then she climbs upon the ships and kills the sleeping mariners.

Prudence

THE ANT, by her natural foresight, provides in the summer for the winter, killing the seeds she harvests that they may not germinate, and on them in due time she feeds.

Folly

THE WILD BULL having a horror of a red colour, the hunters dress up the trunk of a tree with red and the bull runs at this with great frenzy, thus fixing his horns, and forthwith the hunters kill him there.

Justice

We may liken the virtue of Justice to the king of THE BEES, which orders and arranges every thing with judgment. For some bees are ordered to go to the flowers, others are ordered to labour, others to fight with the wasps, others to clear away all dirt, others to accompany and escort the king; and when he is old and has no wings they carry him. And if one of them fails in his duty, he is punished without reprieve.

Truth

Although PARTRIDGES steal each other's eggs, nevertheless the young born of these eggs always return to their true mother.

Fidelity

THE CRANES are so faithful and loyal to their king that at night, when he is sleeping, some of them go round the field to keep watch at a distance; others remain near, each holding a stone in his foot, so that if sleep should overcome them, this stone would fall and make so much noise that they would wake up again. And there are others which sleep together round the king; and this they do every night, changing in turn so that their king may never find them wanting.

Duplicity

THE FOX when it sees a flock of herons or magpies or birds of that kind, suddenly flings himself on the ground with his mouth open to look as he were dead; and these birds want to peck at his tongue, and he bites off their heads.

Lies

THE MOLE has very small eyes and it always lives under ground; and it lives as long as it is in the dark but when it comes into the light it dies immediately, because it becomes known;—and so it is with lies.

Fear

THE HARE is always frightened; and the leaves that fall from the trees in autumn always keep him in terror and generally put him to flight.

Magnanimity

THE FALCON never preys but on large birds; and it will let itself die rather than feed on little ones, or eat stinking meat.

Vainglory

As regards this vice, we read that THE PEACOCK is more guilty of it than any other animal. For it is always contemplating the beauty of its tail, which it spreads in the form of a wheel, and by its cries attracts to itself the gaze of the creatures that surround it. And this is the last vice to be conquered.

Leonardo's Bestiary

Constancy

Constancy may be symbolised by THE PHOENIX which, knowing that by nature it must be resuscitated, has the constancy to endure the burning flames which consume it, and then it rises anew.

Inconstancy

THE SWALLOW may serve for inconstancy, for it is always in movement, since it cannot endure the smallest discomfort.

Temperance

THE CAMEL is the most lustful animal there is, and will follow the female for a thousand miles. But if you keep it constantly with its mother or sister it will leave them alone, so temperate is its nature.

Intemperance

THE UNICORN, through its intemperance and not knowing how to control itself, for the love it bears to fair maidens forgets its ferocity and wildness; and laying aside all fear it will go up to a seated damsel and go to sleep in her lap, and thus the hunters take it.

Humility

We see the most striking example of humility in THE LAMB, which will submit to any animal; and when they are given for food to imprisoned lions they are as gentle to them as to their own mother, so that very often it has been seen that the lions forbear to kill them.

Abstinence

THE WILD ASS, when it goes to the well to drink and finds the water troubled, is never so thirsty but that it will abstain from drinking, and wait till the water is clear again.

Gluttony

THE VULTURE is so addicted to gluttony that it will go a thousand miles to eat a carrion; therefore is it that it follows armies.

Chastity

THE TURTLE-DOVE is never false to its mate, and if one dies the other preserves perpetual chastity, and never again sits on a green bough, nor ever again drinks of clear water.

Promiscuity

THE BAT, owing to unbridled lust, observes no universal rule in pairing, but males with males and females with females pair promiscuously, as it may happen.

Moderation

THE ERMINE out of moderation never eats but once in the day; it will rather let itself be taken by the hunters than take refuge in a dirty lair, in order not to stain its purity.

Fame

THE LUMERPA is found in Asia Major, and shines so brightly that it absorbs its own shadow, and when it dies it does not lose this light, and its feathers never fall out, but a feather pulled out shines no longer. [a]

Treachery

THE OYSTER, when the moon is full, opens itself wide, and when the crab looks in he throws in a piece of rock or seaweed and the oyster cannot close again,

[a] The lumerpa is one of the rarest creatures in Leonardo's bestiary: there is no obvious source for a bird of this name. It is probably based on the legend of the phoenix, the firebird of ancient Egypt. This creature mutated into a number of exotically glowing birds as it crossed both centuries and continents. One of the most notable, the *zhar-ptitsa*, comes from Russian folklore. Leonardo may have had this creature in mind, because Asia Major was the ancient term for the lands of present-day Russia and Ukraine. The Russian firebird was made famous in Igor Stravinsky's 1910 ballet *The Firebird*.

whereby it serves for food to that crab. This is what happens to him who opens his mouth to tell his secret. He becomes the prey of the treacherous hearer.

Hypocrisy

THE CROCODILE catches a man and straightway kills him; after he is dead, it weeps for him with a lamentable voice and many tears. Then, having done lamenting, it cruelly devours him. It is thus with the hypocrite, who, for the smallest matter, has his face bathed with tears, but shows the heart of a tiger and rejoices in his heart at the woes of others, while wearing a pitiful face.

Foresight

THE COCK does not crow till it has thrice flapped its wings; the parrot in moving among boughs never puts its feet excepting where it has first put its beak. Vows are not made till Hope is dead.

Virtue in general

THE CATERPILLAR, which, by means of assiduous care, is able to weave round itself a new dwelling place with marvellous artifice and fine workmanship, comes out of it afterwards with painted and lovely wings, with which it rises towards Heaven.

THE *Swan* is white without any spot, and it sings sweetly as it dies, its life ending with that song.

THE *Stork,* by drinking saltwater, purges itself of distempers. If the male finds his mate unfaithful, he abandons her; and when it grows old its young ones brood over it, and feed it till it dies.

THE *Grasshopper* silences the cuckoo with its song. It dies in oil and revives in vinegar. It sings in the greatest heats.

THE *Bat*. The more light there is, the blinder this creature becomes; as those who gaze most at the sun become most dazzled.—For Vice, that cannot remain where Virtue appears.

THE *Swallow*. This bird gives sight to its blind young ones by means of celandine.

THE *Scorpion*. Saliva, spit out when fasting, will kill a scorpion. This may be likened to abstinence from greediness, which removes and heals the ills which result from that gluttony, and opens the path of virtue.

THE *Toad* flies from the light of the sun, and if it is held there by force it puffs itself out so much as to hide its head below and shield itself from the rays. Thus does the foe of clear and radiant virtue, who can only be brought to face it with puffed up courage.

THE *Spider* brings forth out of herself the delicate and ingenious web, which repays her by the prey it takes.

THE *Lion*, with his thundering roar, rouses his young the third day after they are born, teaching them the use of all their dormant senses and all the wild things which are in the wood flee away.

 This may be compared to the children of Virtue who are roused by the sound of praise and grow up in honourable studies, by which they are more and more elevated; while all that is base flies at the sound, shunning those who are virtuous.

Again, the lion covers over its foot tracks, so that the way it has gone may not be known to its enemies. Thus it beseems a captain to conceal the secrets of his mind so that the enemy may not know his purpose.

THE BITE OF THE *Tarantula* fixes a man's mind on one idea; that is on the thing he was thinking of when he was bitten.

THE *Screech-owl* AND THE *Owl* punish those who are scoffing at them by pecking out their eyes; for nature has so ordered it, that they may thus be fed.

THE HUGE *Elephant* has by nature what is rarely found in man; that is Honesty, Prudence, Justice, and the Observance of Religion; inasmuch as when the moon is new, these beasts go down to the rivers, and there, solemnly cleansing themselves, they bathe, and so, having saluted the planet, return to the woods. And when they are ill, being laid down, they fling up plants towards Heaven as though they would offer sacrifice.

They bury their tusks when they fall out from old age. Of these two tusks they use one to dig up roots for food; but they save the point of the other for fighting with; when they are taken by hunters and when worn out by fatigue, they dig up these buried tusks and ransom themselves.

They are merciful, and know the dangers, and if one finds a man alone and lost, he kindly puts him back in the road he has missed, if he finds the footprints of the man before the man himself. It dreads betrayal, so it stops and blows, pointing it out to the other elephants who form in a troop and go warily.

These beasts always go in troops, and the oldest goes in front and the second in age remains the last, and thus they enclose the troop. Out of shame they pair only at night and secretly, nor do they then rejoin the herd but first bathe in the river. The females do not fight as with other animals; and it is so merciful that it is most unwilling by nature ever to hurt those weaker than itself. And if it meets in the middle of its way a flock of sheep it puts them aside with its trunk, so as not to trample them under foot; and it never hurts any thing unless when

provoked. When one has fallen into a pit the others fill up the pit with branches, earth and stones, thus raising the bottom that he may easily get out. They greatly dread the noise of swine and fly in confusion, doing no less harm then, with their feet, to their own kind than to the enemy. They delight in rivers and are always wandering about near them, though on account of their great weight they cannot swim. They devour stones, and the trunks of trees are their favourite food. They have a horror of rats. Flies delight in their smell and settle on their back, and the beast scrapes its skin, making its folds even, and kills them.

When they cross rivers they send their young ones up against the stream of the water; thus, being set towards the fall, they break the united current of the water so that the current does not carry them away. The dragon flings itself under the elephant's body, and with its tail it ties its legs; with its wings and with its arms it also clings round its ribs and cuts its throat with its teeth, and the elephant falls upon it and the dragon is burst. Thus, in its death it is revenged on its foe.

THE *Serpent* is a very large animal. When it sees a bird in the air it draws in its breath so strongly that it draws the birds into its mouth too. Marcus Regulus, the consul of the Roman army, was attacked, with his army, by such an animal and almost defeated. And this animal, being killed by a catapult, measured 123 feet, that is 64 ½ braccia, and its head was high above all the trees in a wood. [b]

THE *Bison.* This beast is a native of Paeonia and has a neck with a mane like a horse. In all its other parts it is like a bull, excepting that its horns are in a way bent inwards so that it cannot butt; hence it has no safety but in flight, in which it flings out its excrement to a distance of 400 braccia in its course, and this burns like fire wherever it touches. [c]

[b] In his *History of Rome*, Livy describes how in 255 BCE, during the First Punic War, Marcus Atilius Regulus, a Roman general, attacked the Carthaginians in Africa. He and his men encountered and killed a giant serpent in the River Bagradas, in modern-day Tunisia. Pliny reports that a number of Roman soldiers were crushed in its jaws or killed by its tail, and it took the entire army to subdue it. The jaws and skin, said to be 120 feet long, were later put on display in Rome. The braccia was a Florentine measurement; 1 braccia = 23 inches.

[c] Paeonia is now northern Greece, western Bulgaria and Macedonia.

THE *Lioness.* When the lioness defends her young from the hand of the hunter, in order not to be frightened by the spears, she keeps her eyes on the ground to the end, that she may not by her flight leave her young ones prisoners.

THE *Panther* IN AFRICA. This has the form of the lioness but it is taller on its legs and slimmer and long bodied; and it is all white and marked with black spots after the manner of rosettes; and all animals delight to look upon these rosettes, and they would always be standing round it if it were not for the terror of its face; therefore knowing this, it hides its face, and the surrounding animals grow bold and come close, the better to enjoy the sight of so much beauty; when suddenly it seizes the nearest and at once devours it.

THE *Tiger.* This beast is a native of Hyrcania, and it is something like the panther from the various spots on its skin. It is an animal of terrible swiftness; the hunter when he finds its young ones carries them off hastily, placing mirrors in the place whence he takes them, and at once escapes on a swift horse. The panther returning finds the mirrors fixed on the ground and looking into them believes it sees its young; then scratching with its paws it discovers the cheat. Forthwith, by means of the scent of its young, it follows the hunter, and when this hunter sees the tigress he drops one of the young ones and she takes it, and having carried it to the den she immediately returns to the hunter and does the same till he gets into his boat. ᵈ

THE *Weasel,* finding the lair of the basilisk, kills it with the smell of its urine, and this smell, indeed, often kills the weasel itself.

THE *Cerastes* has four movable little horns; so, when it wants to feed, it hides under leaves all of its body except these little horns which, as they move, seem to the birds to be some small worms at play. Then they immediately swoop down

ᵈ Hyrcania ("Wolf's Land") is now northern Iran.

to pick them and the cerastes suddenly twines round them and encircles and devours them. [e]

THE *Amphisboena* has two heads, one in its proper place, the other at the tail; as if one place were not enough from which to fling its venom. [f]

THE *Ichneumon.* This animal is the mortal enemy of the asp. It is a native of Egypt and when it sees an asp near its place, it runs at once to the bed or mud of the Nile and with this makes itself muddy all over, then it dries itself in the sun, smears itself again with mud, and thus, drying one after the other, it makes itself three or four coatings like a coat of mail. Then it attacks the asp, and fights well with him, so that, taking its time it catches him in the throat and destroys him. [g]

THE *Asp.* The bite of this animal cannot be cured unless by immediately cutting out the bitten part. This pestilential animal has such a love for its mate that they always go in company. And if, by mishap, one of them is killed, the other, with incredible swiftness, follows him who has killed it; and it is so determined and eager for vengeance that it overcomes every difficulty, and passing by every troop it seeks to hurt none but its enemy. And it will travel any distance, and it is impossible to avoid it unless by crossing water and by very swift flight. It has its eyes turned inwards, and large ears, and it hears better than it sees.

[e] The cerastes is a venomous, two-foot-long snake found in the desert regions of northern Africa and the Middle East. As Leonardo points out, it has horn-like protrusions on its head and often conceals itself in the sand.

[f] In his *Natural History*, Pliny the Elder describes the amphisboena (or amphisbaena) as a serpent with two heads, one on the end of its tail. Its name comes from the Greek "to go both ways." It was often illustrated in medieval bestiaries.

[g] The ichneumon is an Egyptian mongoose. Leonardo takes from Pliny the report that it improvises a suit of armor from successive coats of Nile mud before attacking the asp.

THE *Dolphin.* Nature has given such knowledge to animals that besides the consciousness of their own advantages they know the disadvantages of their foes. Thus the dolphin understands what strength lies in a cut from the fins placed on his spine, and how tender is the belly of the crocodile; hence in fighting with him it thrusts at him from beneath and rips up his belly and so kills him. The crocodile is a terror to those that flee, and a base coward to those that pursue him.

THE *Hippopotamus.* This beast when it feels itself over-full goes about seeking thorns, or where there may be the remains of canes that have been split, and it rubs against them till a vein is opened; then when the blood has flowed as much as he needs, he plasters himself with mud and heals the wound. In form he is something like a horse with long haunches, a twisted tail and the teeth of a wild boar, his neck has a mane; the skin cannot be pierced, unless when he is bathing; he feeds on plants in the fields and goes into them backwards, so that it may seem as though he had come out.

THE *Panther* after its bowels have fallen out will still fight with the dogs and hunters.

THE *Chameleon* always takes the colour of the thing on which it is resting, whence it is often devoured together with the leaves on which the elephant feeds.

THE *Ibis.* This bird resembles a crane, and when it feels itself ill it fills its craw with water, and with its beak makes an injection of it.

Dragons. These go in companies together, and they twine themselves after the manner of roots, and with their heads raised they cross lakes, and swim to where they find better pasture; and if they did not thus combine they would be drowned, therefore they combine.

THE *Macli:* CAUGHT WHEN ASLEEP. This beast is born in Scandinavia. It has the shape of a great horse, excepting that the great length of its neck and of its ears make a difference. It feeds on grass, going backwards, for it has so long an upper lip that if it went forwards it would cover up the grass. Its legs are all in one piece; for this reason when it wants to sleep it leans against a tree, and the hunters, spying out the place where it is wont to sleep, saw the tree almost through, and then, when it leans against it to sleep, in its sleep it falls, and thus the hunters take it. And every other mode of taking it is in vain, because it is incredibly swift in running. [h]

Catoblepas. It is found in Ethiopia near to the source Nigricapo. It is not a very large animal, is sluggish in all its parts, and its head is so large that it carries it with difficulty, in such wise that it always droops towards the ground; otherwise it would be a great pest to man, for any one on whom it fixes its eyes dies immediately. [i]

THE *Basilisk.* This is found in the province of Cyrenaica and is not more than 12 fingers long. It has on its head a white spot after the fashion of a diadem. It scares all serpents with its whistling. It resembles a snake, but does not move by wriggling but from the centre forwards to the right. It is said that one of these, being killed with a spear by one who was on horse-back, and its venom flowing on the spear, not only the man but the horse also died. It spoils the wheat and not only that which it touches, but where it breathes the grass dries and the stones are split. [j]

[h] The macli was probably a reindeer or elk. The vulnerability of the macli is usually attributed to the elephant. Luigi Pulci's epic poem *Morgante* (a book Leonardo owned) describes the giant Morgante catching an elephant in this manner.

[i] The catoblepas, described by Pliny as having the body of a buffalo and the head of a hog, may have been a creature such as a wildebeest or a gnu. Its name means "that which looks downwards." Pliny writes that it lived in western Ethiopia. The Nigricapo is the source of the Niger River in Africa.

[j] The basilisk is also described in Pliny's *Natural History*. He calls it a creature "which the very serpents fly from, which kills by its odour even, and which proves fatal to man by only looking upon him." Cyrenaica is the western coastal region of modern-day Libya.

Randomness and Absurdity

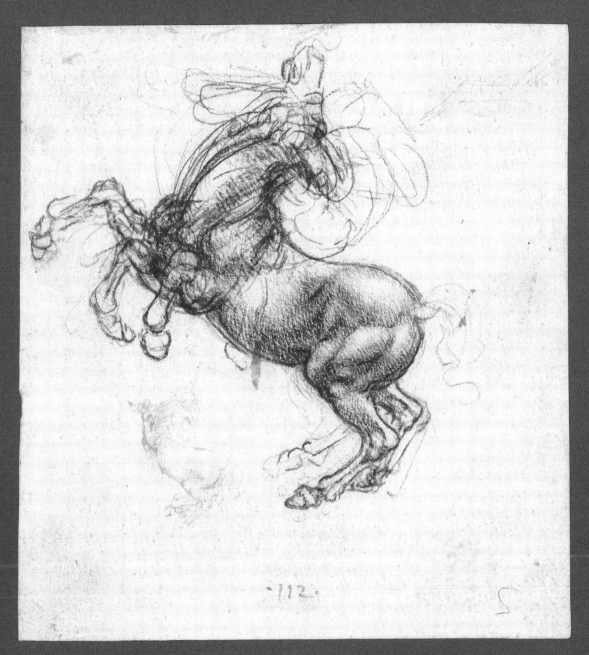

Fables and Jests

Randomness...

hile Leonardo's "Book of Beasts" made use of many earlier books, his fables show more originality. "There can be no doubt," wrote Jean Paul Richter, who edited Leonardo's writings in 1883, "that the fables are the original offspring of Leonardo's brain, and not borrowed from any foreign source." There were certainly many sources he could have borrowed from. The *Fior di Virtù* included numerous fables about animals, as did another book in his library, *Aesop's Fables*. But recent scholarship confirms Richter's claims for Leonardo's originality.

The fable was one of the oldest and most durable literary forms in Europe, stretching back some two thousand years. Aesopian fables were extremely popular in Italy during the Middle Ages and Renaissance. Even Dante read them. "I was thinking over one of Aesop's fables," he writes in Canto XXIII of *The Inferno*, " ... where he tells the story of the frog and the mouse." Aesop did not actually write the fable of the frog and the mouse, but Dante attributes it to him for the simple reason that in the Middle Ages almost all fables were attributed to Aesop. His name—then as now—was virtually synonymous with the genre.

Little is known about the historical Aesop. He seems to have lived in Greece in the middle of the sixth century BCE. According to a medieval Byzantine monk named Planudes Maximus, he was a slave from the island of Samos. He

was exactly the sort of fellow Leonardo would have followed through the streets since, according to Planudes, he was "extremely ugly to look at, filthy, with a big fat belly and a big fat head, snub-nosed, misshapen, dark-skinned, dwarfish, flat-footed, bandy-legged, short-armed, squint-eyed, fat-lipped, in short, a freak of nature." This unprepossessing character, wise and irreverent, supposedly became advisor to the King of Babylon. His wit and wisdom spread through the ancient world to such an extent that Socrates spent his last hours adapting Aesop's fables into verse. Aesop was popular with other philosophers too. A former student of Aristotle and governor of Athens, Demetrius Phalereus, eventually compiled many of the fables. This anthology was edited by scholars at Alexandria, where Demetrius had founded the Royal Library. Several centuries later, it was turned into Latin verse by a poet named Phaedrus.

Aesop-like fables appeared regularly over the next thousand years. Latin versions of Aesop were popular for teaching rhetoric and morality in medieval schools, and the fables were quoted in sermons and illustrated in manuscripts. Even the great fifteenth-century architect Leon Battista Alberti wrote a collection of fables in emulation of Aesop. With the invention of the printing press in the middle of the fifteenth century, Aesop spread even more swiftly and widely across Europe. One of the first books ever printed in German, in 1461, was an edition of Aesop's fables called *Der Edelstein* ("The Precious Stone"). Fifteen years later, another German edition, called *Esopus*, was quickly translated into Dutch, French, Italian, Spanish and Czech.

The fables, as recorded by Phaedrus and repeated down the centuries, involve talking animals whose interactions reveal human virtues and vices, together with examples of foolish behavior and poor judgment. The lion, for example, represents strength but also arrogance, the lamb meekness, and the fox cunning and hypocrisy. According to Phaedrus, Aesop resorted to this sort of allegory for political reasons, since as a slave he "dared not say outright what he wished to say" and therefore "eluded censure under the guise of jesting with made-up stories."

Aesop's fables may well have contained political messages in certain contexts. In 1249, a tyrant in Padua named Ezelino da Romano threw a man in jail for reciting Aesop in public. But the key to the Aesopian fable is usually not any overtly political message so much as a moral one. If a joke has a punch line, a fable ends with an ethical lesson. William Caxton, who translated Aesop into English in 1484, made certain his readers did not miss the point of the stories. He concluded Aesop's fable of the wolf and the dog (in which the wolf envies the fat dog his nice dinners until he notices the iron collar on his neck) with the emphatic statement: "Therfore there is no rychesse gretter than lyberte / For lyberte is better than alle the gold of the world."

Many fables are deeply pessimistic. Lines Cottegnies, an historian of fables, has noted how the world of Aesop "is one of injustice and cruelty, a world reflecting the victory of might over right In fable after fable, it appears that Aesop's animal society is consistently ruled by passions such as vanity, envy, hypocrisy and ungratefulness, and warped by stupidity." Leonardo does nothing to alter this tradition. He himself was often despondent about humanity, as evidenced by his famous comments about the "beastly madness" of war and his obsession, later in his life, with drawing and describing apocalyptic floods.

This dark vision informs many of Leonardo's fables. As Kenneth Clark has written: "The animals, plants, or inanimate objects, who are the heroes of the fables, are no sooner confident of success and security than they are utterly destroyed by some superior and usually unconscious agency. If they avoid one misfortune, they immediately fall victim to a far greater disaster as a result of their previous cunning." Leonardo's fables expose the natural world as a place of envy,

mockery, enmity, competition and ironic reversals of fate. Strangely for a man who loved birds, the avian world is shown to be particularly aggressive and hostile.

We also find in many of Leonardo's fables what appears to be a conservative message. The fables repeatedly warn against aspiring to something better, to leaving one's home or place of comfort to venture somewhere that looks more appealing. This, at least, appears to be the moral of the stories about the flea and the dog, the butterfly and the candle, the pebble in the road, and the glassblower's flame. The message is made explicit at the end of the fable of the pebble that unwisely leaves the "delightful grove" to join the other stones on a busy road. Here, suddenly, it is subjected to the traffic of cartwheels and the dung of animals. Leonardo spells out the point of the story: "Thus it happens to those who choose to leave a life of solitary contemplation, and come to live in cities among people full of infinite evil." In this statement we can perhaps glimpse the sorrow of a man forced to leave the pastoral delights of Vinci to ply his trade in the bustling and sometimes brutal cities of Florence, Milan and Rome.

It seems to be a story about absurdity and randomness. As such, it looks forward to the twentieth century, and to the fables of Franz Kafka and Albert Camus.

Leonardo dreamed both of flying through the air and—thanks to his plans for a diving bell and a submarine—traveling under water. Surprisingly, however, some of his fables warn against leaving one's own element and entering another. Destruction, it seems, awaits anyone who transgresses his natural boundaries of earth, air, fire or water. The butterfly, "not content with being able to fly at its ease through the air," flies into a flame and is scorched. The falcon is drowned when it pursues the duck into the water. Water, wanting to rise above the air, falls to the ground as rain.

As the falcon's disastrous pursuit of the duck indicates, one of Leonardo's other favorite motifs is that of *caccia al cacciatore,* or "the hunter hunted." His fables are full of reversals of fortune in which the links in the food chain are made painfully clear. In one typical fable, a rat is besieged in its hole by a weasel. The weasel is eaten by a cat, but no sooner does the rat celebrate his newfound liberty than he is "deprived of it, together with his life, by the cruel claws and teeth of the lurking cat." Nature is always red in tooth and claw in the world of Leonardo's fables.

The most disturbing of Leonardo's fables are those that warn of the danger of nurturing a viper in the bosom. The campanile that compassionately gives succor to the nut, only to be destroyed by it, is typical of this dark view of charity. No good deed goes unpunished in Leonardo's world. Perhaps even more sobering is his fable of the willow tree that offers to treat the seeds of the gourd "exactly as though they were my own flesh and blood." It is then strangled and destroyed by the growing plants.

The fable of the willow and the gourd is so upsetting because it enacts a family drama where a parent is sabotaged or annihilated by the children. Leonardo's bestiary included similarly disquieting images of family life: the pigeon that kills its father and mates with its mother is the most striking example. The theme continues in the fable of the fig tree destroyed for the sake of its fruit, or what Leonardo calls its "offspring." The moral is delivered by the elm tree: "O fig-tree! which was best, to be without offspring, or to be brought by them into so miserable a plight!" Children, Leonardo appears to suggest, bring anxiety and destruction upon their parents. He offers stern advice for parents in the fable of the monkey who steals the bird from its nest. Smitten by the fledgling, the monkey "took to kissing it, and from excess of love he kissed it so much and turned it about and squeezed it till he killed it." Once again, the moral is clear: "This is said for those who by not punishing their children let them come to mischief." Spare the rod, Leonardo clearly believes, and spoil the child.

Some of the fables simply hint at the absurdity of the world. How else can we read the story—told in the most laconic fashion—of the ass that fell asleep on the frozen lake, only for the warmth of its body to melt the ice? The unfortunate beast "awoke under water to his great grief, and was forthwith drowned." What is the moral here—that one should never sleep on a frozen lake? It seems, rather, to be a story about absurdity and randomness. As such, it looks forward to the twentieth century, and to the fables of Franz Kafka and Albert Camus.

However dark some of the fables, they offer a revealing portrait of the Italian countryside that Leonardo, the boy from Vinci, knew so well. We see how figs, peaches and nuts are picked from trees, how the Tuscan countryside is crossed by troops of soldiers, and how eagles and other birds are trapped with bird-lime— a gooey substance made from boiled holly bark and smeared on tree branches. (Machiavelli used bird-lime to catch thrushes on his farm.) We also learn, in one of the few references to art, how the wood of the pear tree was used by sculptors. Leonardo takes all of these everyday events and spins them into imaginative stories with their comic moments, miniature tragedies and sad lessons.

Leonardo's Fables

Fables on Animals

THE hrushes rejoiced greatly at seeing a man take the owl and deprive her of liberty, tying her feet with strong bonds. But this owl was afterwards by means of bird-lime the cause of the thrushes losing not only their liberty, but their life. This is said for those countries which rejoice in seeing their governors lose their liberty, when by that means they themselves lose all succour, and remain in bondage in the power of their enemies, losing their liberty and often their life.

A og, lying asleep on the fur of a sheep, one of his fleas, perceiving the odour of the greasy wool, judged that this must be a land of better living, and also more secure from the teeth and nails of the dog than where he fed on the dog; and without further reflection he left the dog and went into the thick wool. There he began with great labour to try to pass among the roots of the hairs; but after much sweating had to give up the task as vain, because these hairs were so close that they almost touched each other, and there was no space where fleas could taste the skin. Hence, after much labour and fatigue, he began to wish to return to his dog, who however had

already departed; so he was constrained after long repentance and bitter tears, to die of hunger.

THE

ain and wandering butterfly, not content with being able to fly at its ease through the air, overcome by the tempting flame of the candle, decided to fly into it; but its sportive impulse was the cause of a sudden fall, for its delicate wings were burnt in the flame. And the hapless butterfly having dropped, all scorched, at the foot of the candlestick, after much lamentation and repentance, dried the tears from its swimming eyes, and raising its face exclaimed: "O false light! how many must thou have miserably deceived in the past, like me; or if I must indeed see light so near, ought I not to have known the sun from the false glare of dirty tallow?"

THE

onkey, finding a nest of small birds, went up to it greatly delighted. But they, being already fledged, he could only succeed in taking the smallest; greatly delighted he took it in his hand and went to his abode; and having begun to look at the little bird he took to kissing it, and from excess of love he kissed it so much and turned it about and squeezed it till he killed it. This is said for those who by not punishing their children let them come to mischief.

THE

rab standing under the rock to catch the fish which crept under it, it came to pass that the rock fell with a ruinous downfall of stones, and by their fall the crab was crushed.

A

Rat was besieged in his little dwelling by a weasel, which with unwearied vigilance awaited his surrender, while watching his imminent peril through a little hole. Meanwhile the cat came by and suddenly seized the weasel and forthwith devoured it. Then the rat offered up a sacrifice to Jove of some of his store of nuts, humbly thanking His providence, and came out of his hole to enjoy his lately lost liberty. But he was instantly deprived of it, together with his life, by the cruel claws and teeth of the lurking cat.

A

Spider found a bunch of grapes which for its sweetness was much resorted to by bees and divers kinds of flies. It seemed to her that she had found a most convenient spot to spread her snare, and having settled herself on it with her delicate web, and entered into her new habitation, there every day placing herself in the openings made by the spaces between the grapes, she fell like a thief on the wretched creatures which were not aware of her. But, after a few days had passed, the vintager came, and cut away the bunch of grapes and put it with others, with which it was trodden; and thus the grapes were a snare and pitfall both for the treacherous spider and the betrayed flies.

A

Falcon, unable to endure with patience the disappearance of a duck, which, flying before him had plunged under water, wished to follow it under water, and having soaked his feathers had to remain in the water while the duck, rising to the air, mocked at the falcon as he drowned.

A N

Ass having gone to sleep on the ice over a deep lake, his heat dissolved the ice and the ass awoke under water to his great grief, and was forthwith drowned.

THE

nt found a grain of millet. The seed feeling itself taken prisoner cried out to her: "If you will do me the kindness to allow me to accomplish my function of reproduction, I will give you a hundred such as I am." And so it was.

Fables on Lifeless Objects

THE

et that was wont to take the fish was seized and carried away by the rush of fish.

THE

orrent carried so much earth and stones into its bed, that it was then constrained to change its course.

THE

ater finding that its element was the lordly ocean, was seized with a desire to rise above the air, and being encouraged by the element of fire and rising as a very subtle vapour, it seemed as though it were really as thin as air. But having risen very high, it reached the air that was still more rare and cold, where the fire forsook it, and the minute particles, being brought together, united and became heavy; whence its haughtiness deserting it, it betook itself to flight and it fell from the sky, and was drunk up by the dry earth, where, being imprisoned for a long time, it did penance for its sin.

THE

azor having one day come forth from the handle which serves as its sheath and having placed himself in the sun, saw the sun reflected in his body, which filled him with great pride. And turning it over in his thoughts he began to say to himself: "And shall I return again to that shop from which I have just come? Certainly not; such splendid beauty shall not, please God, be turned to such base uses. What folly it would be that could lead me to shave the lathered beards of rustic peasants and perform such menial service! Is this body destined for such work? Certainly not. I will hide myself in some retired spot and there pass my life in tranquil repose." And having thus remained hidden for some months, one day he came out into the air, and issuing from his sheath, saw himself turned to the similitude of a rusty saw while his surface no longer reflected the resplendent sun. With useless repentance he vainly deplored the irreparable mischief, saying to himself: "Oh! how far better was it to employ at the barbers my lost edge of such exquisite keenness! Where is that lustrous surface? It has been consumed by this vexatious and unsightly rust."

The same thing happens to those minds which instead of exercise give themselves up to sloth. They are like the razor here spoken of, and lose the keenness of their edge, while the rust of ignorance spoils their form.

A

tone of some size recently uncovered by the water lay on a certain spot somewhat raised, and just where a delightful grove ended by a stony road; here it was surrounded by plants decorated by various flowers of divers colours. And as it saw the great quantity of stones collected together in the roadway below, it began to wish it could let itself fall down there, saying to itself: "What have I to do here with these plants? I want to live in the company of those, my sisters." And letting itself fall, its rapid course ended among these longed-for companions. When it had been there sometime it began to find itself constantly toiling under the wheels of the carts of the iron-shoed feet of horses and of travellers. This one rolled it over, that one trod upon it;

sometimes it lifted itself a little and then it was covered with mud or the dung of some animal, and it was in vain that it looked at the spot whence it had come as a place of solitude and tranquil place. Thus it happens to those who choose to leave a life of solitary comtemplation, and come to live in cities among people full of infinite evil.

SOME

lames had already lasted in the furnace of a glass-blower, when they saw a candle approaching in a beautiful and glittering candlestick. With ardent longing they strove to reach it; and one of them, quitting its natural course, writhed up to an unlit torch on which it fed and passed at the opposite end out by a narrow chink to the candle, which was near. It flung itself upon it, and with fierce jealousy and greediness it devoured it, having reduced it almost to death, and, wishing to procure the prolongation of its life, it tried to return to the furnace whence it had come. But in vain, for it was compelled to die, the wood perishing together with the candle, being at last converted, with lamentation and repentance, into foul smoke, while leaving all its sisters in brilliant and enduring life and beauty.

A

mall patch of snow finding itself clinging to the top of a rock which was lying on the topmost height of a very high mountain and being left to its own imaginings, it began to reflect in this way, saying to itself: "Now, shall not I be thought vain and proud for having placed myself— such a small patch of snow—in so lofty a spot, and for allowing that so large a quantity of snow as I have seen here around me, should take a place lower than mine? Certainly my small dimensions by no means merit this elevation. How easily may I, in proof of my insignificance, experience the same fate as that which the sun brought about yesterday to my companions, who were all, in a few hours, destroyed by the sun. And this happened from their having placed themselves

higher than became them. I will flee from the wrath of the sun, and humble myself and find a place befitting my small importance." Thus, flinging itself down, it began to descend, hurrying from its high home on to the other snow; but the more it sought a low place the more its bulk increased, so that when at last its course was ended on a hill, it found itself no less in size than the hill which supported it; and it was the last of the snow which was destroyed that summer by the sun. This is said for those who, humbling themselves, become exalted.

SEEING

he paper all stained with the deep blackness of ink, it deeply regrets it; and this proves to the paper that the words composed upon it were the cause of its being preserved.

THE

nife, which is an artificial weapon, deprives man of his nails, his natural weapons.

THE

en must necessarily have the penknife for a companion, and it is a useful companionship, for one is not good for much without the other.

 Fables on Plants

THE

ig-tree, having no fruit, no one looked at it; then, wishing to produce fruits that it might be praised by men, it was bent and broken down by them.

THE

edar, being desirous of producing a fine and noble fruit at its summit, set to work to form it with all the strength of its sap. But this fruit, when grown, was the cause of the tall and upright tree-top being bent over.

THE

each, being envious of the vast quantity of fruit which she saw borne on the nut-tree, her neighbour, determined to do the same, and loaded herself with her own in such a way that the weight of the fruit pulled her up by the roots and broke her down to the ground.

THE

ig-tree, standing by the side of the elm and seeing that its boughs were bare of fruit, yet that it had the audacity to keep the Sun from its own unripe figs with its branches, said to it: "Oh elm! art thou not ashamed to stand in front of me? But wait till my offspring are fully grown and you will see where you are!" But when her offspring were mature, a troop of soldiers coming by fell upon the fig-tree, and her figs were all torn off her, and her boughs cut away and broken. Then, when she was thus maimed in all her limbs, the elm asked her, saying: "O fig-tree! which was best, to be without offspring, or to be brought by them into so miserable a plight!"

THE

lant complains of the old and dry stick which stands by its side and of the dry stakes that surround it. One keeps it upright, the other keeps it from low company.

A

ut, having been carried by a crow to the top of a tall campanile and released by falling into a chink from the mortal grip of its beak, prayed to the wall for the grace bestowed on it by God in allowing it to be so high and thick, and to own such fine bells and of so noble a tone, that it would succour it, and that, as it had not been able to fall under the verdurous boughs of its venerable father and lie in the fat earth covered up by his fallen leaves it would not abandon it; because, finding itself in the beak of the cruel crow, it had there made a vow that if it escaped from her it would end its life in a little hole. At these words the wall, moved to compassion, was content to shelter it in the spot where it had fallen; and after a short time the nut began to split open and put forth roots between the rifts of the stones and push them apart, and to throw out shoots from its hollow shell; and, to be brief, these rose above the building and the twisted roots, growing thicker, began to thrust the walls apart, and tear out the ancient stones from their old places. Then the wall too late and in vain bewailed the cause of its destruction and in a short time, it wrought the ruin of a great part of it.

THE

rivet, feeling its tender boughs loaded with young fruit, pricked by the sharp claws and beak of the insolent blackbird, complained to the blackbird with pitious remonstrance, entreating her that since she stole its delicious fruits she should not deprive it of the leaves with which it preserved them from the burning rays of the sun, and that she should not divest it of its tender bark by scratching it with her sharp claws. To which the blackbird replied with angry upbraiding: "O, be silent, uncultured shrub! Do you not know that Nature made you produce these fruits for my nourishment; do you not see that you are in the world only to serve me as food; do you not know, base creature, that next winter you will be food and prey for the Fire?" To which words the tree listened patiently, and not without tears.

After a short time the blackbird was taken in a net and boughs were cut to make a cage, in which to imprison her. Branches were cut, among others from the pliant privet, to serve for the small rods of the cage; and seeing herself to be the cause of the blackbird's loss of liberty, it rejoiced and spoke as follows: "O Blackbird, I am here, and not yet burnt by fire as you said. I shall see you in prison before you see me burnt."

THE

aurel and the myrtle seeing the pear tree cut down, cried out with a loud voice: "O pear-tree! whither are you going? Where is the pride you had when you were covered with ripe fruits? Now you will no longer shade us with your mass of leaves." Then the pear-tree replied: "I am going with the husbandman who has cut me down and who will take me to the workshop of a good sculptor, who by his art will make me take the form of Jove the god; and I shall be dedicated in a temple and adored by men in the place of Jove, while you are bound always to remain maimed and stripped of your boughs, which will be placed round me to do me honour."

THE

ine that has grown old on an old tree falls with the ruin of that tree, and through that bad companionship must perish with it.

THE

hesnut, seeing a man upon the fig-tree, bending its boughs down and pulling off the ripe fruits, which he put into his open mouth, destroying and crushing them with his hard teeth, tossed its long boughs and with a noisy rustle exclaimed: "O fig! how much less are you protected by nature than I. See how in me my sweet offspring are set in close

array; first clothed in soft wrappers over which is the hard but softly lined husk; and not content with taking this care of me, and having given them so strong a shelter, on this she has placed sharp and close-set spines so that the hand of man cannot hurt me." Then the fig-tree and her offspring began to laugh and having laughed she said: "I know man to be of such ingenuity that with rods and stones and stakes flung up among your branches, he will bereave you of your fruits; and when they are fallen, he will trample them with his feet or with stones, so that your offspring will come out of their armour, crushed and maimed; while I am touched carefully by their hands, and not like you with sticks and stones."

 THE apless willow, finding that she could not enjoy the pleasure of seeing her slender branches grow or attain to the height she wished, or point to the sky, by reason of the vine and whatever other trees that grew near, but was always maimed and lopped and spoiled, brought all her spirits together and gave and devoted herself entirely to imagination, standing plunged in long meditation and seeking, in all the world of plants, with which of them she might ally herself and which could not need the help of her withes. Having stood for some time in this prolific imagination, with a sudden flash the gourd presented itself to her thoughts, and tossing all her branches with extreme delight, it seemed to her that she had found the companion suited to her purpose, because the gourd is more apt to bind others than to need binding. Having come to this conclusion she awaited eagerly some friendly bird who should be the mediator of her wishes.

Presently seeing near her the magpie she said to him: "O gentle bird! by the memory of the refuge which you found this morning among my branches, when the hungry, cruel, and rapacious falcon wanted to devour you, and by that repose which you have always found in me when your wings craved rest, and by the pleasure you have enjoyed among my boughs, when playing with your companions or making love—I entreat you find the gourd and obtain from her some of her seeds, and tell her that those that are born of them I will treat

exactly as though they were my own flesh and blood; and in this way use all the words you can think of, which are of the same persuasive purport; though, indeed, since you are a master of language, I need not teach you. And if you will do me this service I shall be happy to have your nest in the fork of my boughs, and all your family without payment of any rent."

Then the magpie, having made and confirmed certain new stipulations with the willow,—and principally that she should never admit upon her any snake or polecat,—cocked his tail, and put down his head, and flung himself from the bough, throwing his weight upon his wings; and these, beating the fleeting air, now here, now there, looking about inquisitively, while his tail served as a rudder to steer him, he came to a gourd; then with a handsome bow and a few polite words, he obtained the required seeds, and carried them to the willow, who received him with a cheerful face. And when he had scraped away with his foot a small quantity of the earth near the willow, describing a circle, with his beak he planted the grains, which in a short time began to grow, and by their growth and the branches to take up all the boughs of the willow, while their broad leaves deprived it of the beauty of the sun and sky. And not content with so much evil, the gourds next began, by their rude hold, to drag the ends of the tender shoots down towards the earth, with strange twisting and distortion.

Then, being much annoyed, the willow shook itself in vain to throw off the gourd. After raving for some days in such plans vainly, because the firm union forbade it, seeing the wind come by it commended itself to him. The wind flew hard and opened the old and hollow stem of the willow in two down to the roots, so that it fell into two parts. In vain did it bewail itself, recognising that it was born to no good end.

...and Absurdity

G ian Paolo Lomazzo, in his *Treatise on Painting*, tells the story of how Leonardo once invited a group of peasants to his house. Hoping to study their facial expressions as they laughed, he told them jokes and other "ridiculous things," reducing everyone to helpless laughter. Leonardo's study of the laughing peasants has not come down to us, but smiles and laughter run through his work. According to Vasari, among his earliest artistic productions were clay busts of women laughing. His last known painting, *St. John the Baptist* (now in the Louvre), shows a man smiling knowingly as he points heavenward.

Leonardo was probably the first person in history to give an anatomical description of what happens when we smile. In about 1506 he wrote on a sheet of paper covered with drawings of lips and mouths: "The muscles called the lips of the mouth in narrowing themselves toward their center pull behind them the lateral muscles, and when the lateral muscles pull, so shortening themselves, then they pull behind them the lips of the mouth and so the mouth is extended." It was around this time that he painted the *Mona Lisa*, which features what is perhaps the world's most famous smile.

There was much laughter and joking in the Florence of Leonardo's youth. The year Leonardo moved to Florence, 1469, was the same year that Lorenzo de' Medici, then only twenty years old, became head of the city-state. Lorenzo the

Magnificent (as he became known to history) was both a shrewd political leader and a cultured and enlightened patron of the arts. He had an impeccable education in high-brow classical literature, but he also loved jokes such as those in the *Facezie, Motti e Burle* ("Humorous Remarks, Witticisms and Jokes"), a popular collection of the stories and sayings of a jocular Florentine priest named Arlotto Mainardi. Lorenzo wrote funny verses of his own, composing satires and bawdy carnival songs (400 years later, a Victorian critic primly condemned them for their "gross innuendo" and "carnal impulse"). He also wrote a ribald, Boccaccio-like tale called "The Novella of Giacoppo" in which a Florentine student hatches a plot—which calls for the services of a prostitute and a corrupt priest—to seduce the pliant young wife of a foolish older man.

Like any shrewd politician, Lorenzo had caught the mood of his people. The Italians of the Renaissance—and the Florentines especially—loved to play pranks, tell stories and read fables. The revival of classical learning in Florence went hand-in-hand with a revival of humor. Jokes had been few and far between in medieval writings, and usually they were longwinded and moralistic. But in ancient writers such as Cicero and Macrobius, the Florentines discovered witty stories and pithy anecdotes that made fun of human foibles.

The revival of classical learning in Florence went hand-in-hand with a revival of humor.

The manuscript-hunter and joke-compiler Poggio Bracciolini (1380-1459) believed that in telling funny (and often obscene) stories he was imitating the ancient Greeks and Romans. "I have read that our ancestors, men of the greatest prudence and learning, took delight in jests, pleasantries and anecdotes," he wrote, "and that they received praise rather than blame for this." Telling jokes was all part of the revival of the glories of the ancient world.

Poggio wrote the most famous of all the joke anthologies that appeared in fifteenth-century Italy. His *Liber Facetiarum* ("Book of Funny Stories") was

compiled between 1438 and 1452, and then printed in 1470. These funny stories came from a club, the Bugiale, or "workshop of lies," that Poggio and his friends formed in Rome. Here they told jokes—including many off-color ones—in order to relax and enjoy themselves. A typical one describes a priest hauled before a bishop to explain himself for burying his pet dog in consecrated ground. "My Lord," exclaims the priest, "if you knew the cunning of this dog. His intelligence was more than human in his lifetime, and especially manifest at his death, for he made a will and, knowing you were needy, left you 50 golden ducats." Needless to say, the dog's last resting place remained undisturbed.

One favorite form of Florentine humor—and one clearly shared by Leonardo—was the *beffa*, or practical joke. Italy's greatest teller of funny stories, Giovanni Boccaccio, devoted two whole days to *beffe* in the *Decameron*. One prank involved the Florentine painter Buffalmacco duping a dimwitted fellow artist, Calandrino (whose real name was Nozzo di Perino), into believing in the existence of a stone that would make him invisible; in another, Buffalmacco tricked Calandrino into thinking he was pregnant. Thanks to Boccaccio, Buffalmacco—who painted the frescoes in the Camposanto in Pisa—almost became more famous for his jokes than for his work with a brush.

Boccaccio may have been relating actual stories about Buffalmacco's humorous exploits. There was certainly a great tradition of practical joking in Florentine studios. The architect Filippo Brunelleschi (1377-1446) was likewise renowned as a prankster. One of his jokes in particular enhanced his legendary status. Brunelleschi's victim was a carpenter named Manetto, known because of his size as *Il Grasso*, or "The Fat Man." Brunelleschi's cruel and elaborate prank involved using several collaborators and much clever trickery (including mimicry) to convince the hapless Manetto that he was really someone else entirely, a well-known Florentine named Matteo.

Another artist who enjoyed complicated pranks was Leonardo's contemporary Sandro Botticelli (1445-1510). Vasari tells the story of how one day Botticelli so confused one of his friends, a painter named Biagio, that Biagio

believed he was losing his mind. The trick involved tampering with a painting of the Virgin and eight angels executed by Biagio and sold to an accomplice of Botticelli. While the painting was still in Biagio's studio, Botticelli, unbeknownst to his victim, attached paper hoods to the heads of the angels. The angelic choir was thereby turned into what looked like officials of the Florentine government. When the buyer arrived to view the work, Biagio was aghast at the sight of his transformed picture—though he kept quiet when the man seemed to notice nothing amiss. When the buyer left, Botticelli turned the hood-wearing officials back into angels without Biagio noticing. "Master, I don't know if I'm dreaming or if this is real," the bewildered Biagio confessed when he saw how the angels had mysteriously reappeared. "You are losing your mind, Biagio," the pitiless Botticelli informed him.

Leonardo's pranks with monsters and lizards reveal his own love of jesting. Like Lorenzo the Magnificent, he also enjoyed reading and telling funny stories. Poggio Bracciolini's *Liber Facetiarum* was one of the books on his bookshelves in Milan. Among the other works he is also known to have read are similar collections of funny tales such as Lodovico Carbone's *Cento trenta novelle* ("One Hundred and Thirty Stories") and Franco Sacchetti's *Trecentonovelle* ("Three Hundred Stories").

Leonardo may have intended to produce his own "Book of Funny Stories," since the Codex Atlanticus includes a number of jests. Like his fables and riddles, these date from the first half of the 1490s, when he was at the court of Lodovico Sforza, Duke of Milan, the man for whom he painted the *Last Supper*. Lodovico himself was a prankster. He once concealed clockwork (possibly designed by Leonardo) in the elaborately embroidered jackets of two of his kinsmen; when the pair entered the great hall of the castle, their clothes began to chime. There followed much confusion in the kinsmen and much braying laughter from Lodovico.

Leonardo entertained the Sforza court with music. He performed on the *lira da braccio*, a stringed instrument played with a bow, and he designed for

Lodovico a lyre made from the skull of a horse. Another part of distracting Lodovico and his courtiers in their idle moments involved making them laugh. Most Italian Renaissance courts had fools or jesters (*buffoni*). Lodovico's older brother, Galeazzo Maria, had employed various dwarfs and *buffoni* to amuse himself and his courtiers. Leonardo seems to have become, for Lodovico, an elevated and erudite version of one of these motley-wearing buffoons—someone who lightened the mood in the Sforza Castle. It's likely that he recited aloud many of the jokes, fables and prophecies that make up this volume. The Oxford scholar Cecilia M. Ady, in her book on the Sforza court, claimed that Lodovico's courtiers "hung upon his fables and satires; his epigrams were on everyone's lips." There seems little

Leonardo seems to have become an elevated and erudite version of one of these motley-wearing buffoons.

doubt that Leonardo could easily have reduced the court to tears of laughter, as he did the peasants whom he invited to his house and entertained with stories of "ridiculous things."

Leonardo's Jests

A priest, making the rounds of his parish on Easter Eve, and sprinkling holy water in the houses as is customary, came to a painter's room, where he sprinkled the water on some of his pictures. The painter turned round, somewhat angered, and asked him why this sprinkling had been bestowed on his pictures; then said the priest, that it was the custom and his duty to do so, and that he was doing good; and that he who did good might look for good in return, and, indeed, for better, since God had promised that every good deed that was done on earth should be rewarded a hundred-fold from above. Then the painter, waiting till he went out, went to an upper window and flung a large pail of water on the priest's back, saying: "Here is the reward a hundred-fold from above, which you said would come from the good you had done me with your holy water, by which you have damaged my pictures."

An artizan often going to visit a great gentleman without any definite purpose, the gentleman asked him what he did this for. The other said that he came there to have a pleasure which his lordship could not have; since to him it was a satisfaction to see men greater than himself, as is the way with the populace; while the gentleman could only see men of less consequence than himself; and so lords and great men were deprived of that pleasure.

Franciscan-begging Friars are wont, at certain times, to keep fasts, when they do not eat meat in their convents. But on journeys, as they live on charity, they have license to eat whatever is set before them. Now a couple of these friars on their travels, stopped at an inn, in company with a certain merchant, and sat down with him at the same table, where, from the poverty of the inn, nothing was served to them but a small roast chicken. The merchant, seeing this to be but little even for himself, turned to the friars and said: "If my memory serves me, you do not eat any kind of flesh in your convents at this season." At these words the friars were compelled by their rule to admit, without cavil, that this was the truth; so the merchant had his wish, and ate the chicken, and the friars did the best they could. After dinner the messmates departed, all three together, and after travelling some distance they came to a river of some width and depth. All three being on foot—the friars by reason of their poverty, and the other from avarice—it was necessary by the custom of company that one of the friars, being barefoot, should carry the merchant on his shoulders: so having given his wooden shoes into his keeping, he took up his man. But it so happened that when the friar had got to the middle of the river, he again remembered a rule of his order, and stopping short, he looked up, like Saint Christopher, to the burden on his back and said: "Tell me, have you any money about you?"—"You know I have," answered the other, "How do you suppose that a merchant like me should go about otherwise?" "Alack!" cried the friar, "our rules forbid us to carry any money on our persons," and forthwith he dropped him into the water, which the merchant perceived was a facetious way of being revenged on the indignity he had done them; so, with a smiling face, and blushing somewhat with shame, he peaceably endured the revenge.

It was asked of a painter why, since he made such beautiful figures, which were but dead things, his children were so ugly; to which the painter replied that he made his pictures by day, and his children by night.

A man saw a large sword which another one wore at his side. Said he: "Poor fellow, for a long time I have seen you tied to that weapon; why do you not release yourself, as your hands are untied, and set yourself free?" To which the other replied: "This is none of yours, on the contrary it is an old story." The former speaker, feeling stung, replied: "I know that you are acquainted with so few things in this world, that I thought anything I could tell you would be new to you."

A man gave up his intimacy with one of his friends because his friend often spoke ill of his other friends. The neglected friend, one day lamenting to this former friend, after much complaining, entreated him to say what might be the cause that had made him forget so much friendship. To which he answered: "I will no longer be intimate with you because I love you, and I do not choose that you, by speaking ill of me, your friend, to others, should produce in others, as in me, a bad impression of yourself, by speaking evil to them of me, your friend. Therefore, being no longer intimate together, it will seem as though we had become enemies; and in speaking evil of me, as is your wont, you will not be blamed so much as if we continued to be intimate."

A man said to an acquaintance: "Your eyes are changed to a strange colour." The other replied: "It often happens, but you have not noticed it." "When does it happen?" said the former. "Every time that my eyes see your

ugly face, from the shock of so unpleasing a sight, they suddenly turn pale and change to a strange colour."

An old man was publicly casting contempt on a young one, and boldly showing that he did not fear him; on which the young man replied that his advanced age served him better as a shield than either his tongue or his strength.

A sick man finding himself in *articulo mortis* heard a knock at the door, and asking one of his servants who was knocking, the servant went out, and answered that it was a woman calling herself Madonna Bona. Then the sick man, lifting his arms to Heaven, thanked God with a loud voice, and told the servants that they were to let her come in at once, so that he might see one good woman before he died, since in all his life he had never yet seen one.

A man was desired to rise from bed, because the sun was already risen. To which he replied: "If I had as far to go, and as much to do as he has, I should be risen by now; but having but a little way to go, I shall not rise yet."

A man wishing to prove, by the authority of Pythagoras, that he had formerly been in the world, while another would not let him finish his argument, the first speaker said to the second: "It is by this token that I was formerly here, I remember that you were a miller." The other one, feeling himself stung by these words, agreed that it was true, and that by the same token he remembered that the speaker had been the ass that carried the flour.

Diversion and Paradox

Riddles

Diversion and Paradox

S cattered through Leonardo's notebooks are a series of strange pronouncements that he calls *profetie*, or prophecies, but which could more accurately be described as riddles. Once again Leonardo is making use of a popular tradition in European literature.

The literary riddle goes back at least as far as Homer, who is said by one source to have died from frustration after some boys stumped him with a riddle: "What we see and catch we leave behind; and what we neither see nor catch we carry away." (Answer: the boys were delousing themselves.) Riddles featured prominently in both Greek literature (the riddle of the Sphinx) and the Bible (Samson's riddle to the Philistines). By the Middle Ages, they were a popular form of amusement at European royal courts. Poets matched wits against one another at Charlemagne's court at Aachen in the eighth century, setting and solving riddles in competition with each other. We get a flavor of these riddles from the writings of one of the courtiers, Alcuin of York, in his *Dialogue of Pepin*: Who can kill a man and get away with it? A doctor. Which women are best to marry? Rich ones that die fast.

Leonardo's riddles were undoubtedly written for similar purposes—to divert and amuse the courtiers in Milan. Some of them were apparently done in competition with his friend, the architect Donato Bramante. He must have taken to the intellectual jousting with great gusto, since he loved puzzles, puns and

other brain-twisters. While at the Sforza court he drew a series of pictographs, possibly as decorations for rooms in the Sforza Castle. These were hieroglyphic-like images that worked as rebuses, or visual puns. For example, he illustrated the popular expression *di bene in meglio* (from good to better) by showing marjoram (known in Tuscany as *megliorana*) grafted onto a beanstalk (*bene*). Puns of this sort also appeared in some of his paintings, as, for example, in *Ginevra de' Benci*, painted in the late 1470s and now in the National Gallery in Washington. A juniper (*ginepro*) stands in the background of his portrait of Ginevra as a visual play on her name.

The point of a riddle is to make the familiar look or sound unfamiliar by describing it (as the Sphinx did to Oedipus) in a deliberately vague or perplexing way. Many of Leonardo's riddles follow this tried-and-true method. His riddles about shadows, reflections, clouds, dice and ditches all maintain the technique of giving a clever and baffling description of something we see every day, often revealing the paradoxes and absurdities of things we take for granted. A ditch, for example, is something that, paradoxically, grows in proportion to how it is diminished.

Leonardo specifically calls his riddles prophecies because some of them appear to predict horrible atrocities that will happen in the future: children, for example, will be taken from their parents to have their throats slit and their bodies quartered. The punch line is, of course, that this atrocity is already under way, only the victims are sheep, goats and calves. Riddles force us to look anew at the everyday life around us, and one of the things Leonardo wishes to scrutinize is man's cruelty to animals. His riddles give a catalogue of animals caught in traps, oxen eaten by their owners, and beasts of burden that endure "discomfort, and blows, and goadings, and curses, and great abuse." We also find a squeamishness about eating meat ("Oh! how foul a thing, that we should see the tongue of one animal in the guts of another," he writes of the sausage).

Leonardo's disquiet about eating flesh is based partly on the paradox that life sustains itself on death. "Our life is made by the death of others," he writes

in his notes on physiology. "In dead matter insensible life remains, which, reunited to the stomachs of living beings, resumes life, both sensual and intellectual." The image of the dead coming back to life in our stomachs is surely enough to give second thoughts to even the most enthusiastic gourmand. Leonardo's belief in the sensual and intellectual life of animals beyond death extends to the use of their hides. In one extraordinary riddle he even goes so far as to suggest that animals whose skins are used for vellum maintain a consciousness of what's written on them. This revealing remark—which suggests that animals have souls— clearly places Leonardo outside the later scientific tradition that saw animals in purely mechanical terms.

His riddles maintain the technique of giving a clever and baffling description of something we see every day, often revealing the paradoxes and absurdities of things we take for granted.

Leonardo is equally concerned about man's inhumanity to man. What, he asks in one riddle, comes out of a dark cave and puts the entire human race in great anxiety, peril and death, and leads to robbery, suspicion, treachery, murder and a loss of freedom? His answer is metals, by which he means iron, bronze and precious metals like gold and silver that men extract from the earth. He might have left the riddle there, but he finishes with a despairing flourish: "O monstrous creature! How much better would it be for men that every thing should return to Hell! For this the vast forests will be devastated of their trees; for this endless animals will lose their lives."

Another of the riddles is almost identical in its gloomy spirit about mankind's appetite for destroying the natural world. His answer to what animal fights itself to the death, despoils forest, and persecutes and disturbs everything on earth is, of course, man. Again he finishes with an anguished execration:

"O Earth! why dost thou not open and engulf them in the fissures of thy vast abyss and caverns, and no longer display in the sight of heaven such a cruel and horrible monster." It's ironic that Leonardo designed numerous military machines, and that he probably wrote these words shortly before he went to work as a military engineer for Cesare Borgia, one of Italy's most savage warlords. Unsurprisingly, perhaps, he left Borgia's service after only a short stint, sickened by his master's violent cruelty and condemning the "beastly madness" of war.

Another target in Leonardo's riddles is the incongruities of the Catholic Church. The selling of indulgences, the wealthy religious orders that preach the virtue of poverty, the veneration of statues and saints: Leonardo wants us to take a fresh look at such practices.

Reading his riddles we hear the racket of silk looms, the music of bag-pipes, and the shouts of boys kicking balls made from animal skin.

He was far from alone in his reservations about the Church. Around the same time, Michelangelo—a man who, unlike Leonardo, was sincerely and devoutly religious—wrote a poem lamenting that Christianity had been so corrupted that chalices had been turned into "helmet and sword" and the blood of Christ sold by the bucketful. Both men were writing at the time when the pope was Alexander VI, a man known for his licentiousness and secularism. Their objections to the corruption and hypocrisy of the Church were to be echoed a few years later by Martin Luther, whose words thundered down the centuries.

However bleak, Leonardo's riddles, like his fables, pleasingly evoke the everyday life of the late fifteenth century. We tend to fast-forward Leonardo into the present, and to think of him as a modern man. But these writings portray an age when dice were made from bones, sieves from animal hair, pens from

feathers and lanterns from cow horns. Reading his riddles we hear the racket of silk looms, the music of bag-pipes, and the shouts of boys kicking balls made from animal skin. We see siege guns drawn by buffalo and oxen, and candle-lit funeral processions winding through the streets. We also note his wonder at things such as the international mail service: "Men will speak with each other from the most remote countries, and reply," reads one riddle. Leonardo would surely have gasped with amazement at the technological wonders of our own world—just as he would have been appalled at the continued cruelty and self-destructiveness of what he called the "human monster."

Leonardo's Riddles

*M*en will seem to see new destructions in the sky. The flames that fall from it will seem to rise in it and to fly from it with terror. They will hear every kind of animal speak in human language. They will instantaneously run in person in various parts of the world, without motion. They will see the greatest splendour in the midst of darkness. O! marvel of the human race! What madness has led you thus! You will speak with animals of every species and they with you in human speech. You will see yourself fall from great heights without any harm and torrents will accompany you, and will mingle with their rapid course.
Of Dreaming

*M*any who hold the faith of the Son only build temples in the name of the Mother.
Of Christians

*T*he greatest honours will be paid to men, and much pomp, without their knowledge.
Of Funeral Rites, and Processions, and Lights, and Bells, and Followers

*T*here will be many who will eagerly and with great care and solicitude follow up a thing, which, if they only knew its malignity, would always terrify them.
Of the Avaricious

\mathcal{M}any will be busied in taking away from a thing, which will grow in proportion as it is diminished.
Of the Ditch

\mathcal{A}nd it will be seen in many bodies that by raising the head they swell visibly; and by laying the raised head down again, their size will immediately be diminished.
Of a Weight placed on a Feather-pillow

\mathcal{A}nd many will be hunters of animals, which, the fewer there are the more will be taken; and conversely, the more there are, the fewer will be taken.
Of catching Lice

\mathcal{A}nd many will be busily occupied, though the more of the thing they draw up, the more will escape at the other end.
Of Drawing Water in two Buckets with a single Rope

\mathcal{F}lying creatures will give their very feathers to support men.
Of Feather-beds

\mathcal{A}nd in many parts of the country men will be seen walking on the skins of large beasts.
Of the Soles of Shoes, which are made from the Ox

\mathcal{T}here will be great winds by reason of which things of the East will become things of the West; and those of the South, being involved in the course of the winds, will follow them to distant lands.
Of Sailing in Ships

Men will speak to men who hear not; having their eyes open, they will not see; they will speak to these, and they will not be answered. They will implore favours of those who have ears and hear not; they will make light for the blind.
Of Worshipping the Pictures of Saints

There will be many men who will move one against another, holding in their hands a cutting tool. But these will not do each other any injury beyond tiring each other; for, when one pushes forward the other will draw back. But woe to him who comes between them! For he will end by being cut in pieces.
Of Sawyers

Dismal cries will be heard loud, shrieking with anguish, and the hoarse and smothered tones of those who will be despoiled, and at last left naked and motionless; and this by reason of the mover, which makes every thing turn round.
Of Silk-spinning

In every city, land, castle and house, men shall be seen, who for want of food will take it out of the mouths of others, who will not be able to resist in any way.
Of putting Bread into the Mouth of the Oven and taking it out again

The Earth will be seen turned up side down and facing the opposite hemispheres, uncovering the lurking holes of the fiercest animals.
Of tilled Land

Then many of the men who will remain alive, will throw the victuals they have preserved out of their houses, a free prey to the birds and beasts of the earth, without taking any care of them at all.
Of Sowing Seed

Something will fall from the sky which will transport a large part of Africa which lies under that sky towards Europe, and that of Europe towards Africa, and that of the Scythian countries will meet with tremendous revolutions.
Of the Rains, which, by making the Rivers muddy, wash away the Land

The trees and shrubs in the great forests will be converted into cinder.
Of Wood that burns

Finally the earth will turn red from a conflagration of many days and the stones will be turned to cinders.
Of Kilns for Bricks and Lime

And things will fall with great force from above, which will give us nourishment and light.
Of the Olives which fall from the Olive trees, shedding oil which makes light

That which was at first bound, cast out and rent by many and various beaters will be respected and honoured, and its precepts will be listened to with reverence and love.
Of Flax which works the cure of men

Bodies without souls will, by their contents, give us precepts by which to die well.
Of Books which teach Precepts

We shall see the horns of certain beasts fitted to iron tools, which will take the lives of many of their kind.
Of the Handles of Knives made of the Horns of Sheep

Leonardo's Riddles

*T*here will come a time when no difference can be discerned between colours; on the contrary, everything will be black alike.

Of Night when no Colour can be discerned

*O*ne who by himself is mild enough and void of all offence will become terrible and fierce by being in bad company, and will most cruelly take the life of many men, and would kill many more if they were not hindered by bodies having no soul, that have come out of caverns—that is, breastplates of iron.

Of Swords and Spears which by themselves never hurt any one

*M*any dead things will move furiously, and will take and bind the living, and will ensnare them for the enemies who seek their death and destruction.

Of Snares and Traps

*T*hat shall be brought forth out of dark and obscure caves, which will put the whole human race in great anxiety, peril and death. To many that seek them, after many sorrows they will give delight, and to those who are not in their company, death with want and misfortune. This will lead to the commission of endless crimes; this will increase and persuade bad men to assassinations, robberies and treachery, and by reason of it each will be suspicious of his partner. This will deprive free cities of their happy condition; this will take away the lives of many; this will make men torment each other with many artifices, deceptions and treasons. O monstrous creature! How much better would it be for men that every thing should return to Hell! For this the vast forests will be devastated of their trees; for this endless animals will lose their lives.

Of Metals

*O*ne shall be born from small beginnings which will rapidly become vast. This will respect no created thing, rather will it, by its power, transform almost every thing from its own nature into another.

Of Fire

*T*he masters of estates will eat their own labourers.
Of Oxen, which are eaten

*M*en will be seen so deeply ungrateful that they will turn upon that which has harboured them, for nothing at all; they will so load it with blows that a great part of its inside will come out of its place, and will be turned over and over in its body.
Of beating Beds to renew them

*T*he high walls of great cities will be seen up side down in their ditches.
Of the Reflection of Walls of Cities in the Water of their Ditches

*A*ll the elements will be seen mixed together in a great whirling mass, now borne towards the centre of the world, now towards the sky; and now furiously rushing from the South towards the frozen North, and sometimes from the East towards the West, and then again from this hemisphere to the other.
Of Water, which flows turbid and mixed with Soil and Dust; and of Mist, which is mixed with the Air; and of Fire, which is mixed with its own, and each with each

*A*ll men will suddenly be transferred into opposite hemispheres.
The World may be divided into two Hemispheres at any Point

*A*ll living creatures will be moved from the East to the West; and in the same way from North to South, and vice versa.
The division of the East from the West may be made at any point

*B*odies devoid of life will move by themselves and carry with them endless generations of the dead, taking the wealth from the bystanders.
Of the Motion of Water which carries wood, which is dead

Throughout Europe there will be a lamentation of great nations over the death of one man who died in the East.

Of the Lamentation on Good Friday

Men will walk and not stir, they will talk to those who are not present, and hear those who do not speak.

Of Dreaming

Shapes and figures of men and animals will be seen following these animals and men wherever they flee. And exactly as the one moves the other moves; but what seems so wonderful is the variety of height they assume.

Of a Man's Shadow which moves with him

Many a time will one man be seen as three and all three move together, and often the most real one quits him.

Of our Shadow cast by the Sun, and our Reflection in the Water at one and the same time

Within walnuts and trees and other plants vast treasures will be found, which lie hidden there and well guarded.

Of wooden Chests which contain great Treasures

Many persons puffing out a breath with too much haste, will thereby lose their sight, and soon after all consciousness.

Of putting out the Light when going to Bed

In many parts of Europe instruments of various sizes will be heard making divers harmonies, with great labour to those who hear them most closely.

Of the Bells of Mules, which are close to their Ears

The severest labour will be repaid with hunger and thirst, and discomfort, and blows, and goadings, and curses, and great abuse.
Of Asses

Many men will be seen carried by large animals, swift of pace, to the loss of their lives and immediate death. In the air and on earth animals will be seen of divers colours furiously carrying men to the destruction of their lives.
Of Soldiers on horseback

The motions of a dead thing will make many living ones flee with pain and lamentation and cries.
Of a Stick, which is dead

With a stone and with iron things will be made visible which before were not seen.
Of Tinder

We shall see the trees of the great forests of Taurus and of Sinai and of the Appenines and others, rush by means of the air, from East to West and from North to South; and carry, by means of the air, great multitudes of men. Oh! how many vows! Oh! how many deaths! Oh! how many partings of friends and relations! Oh! how many will those be who will never again see their own country nor their native land, and who will die unburied, with their bones strewn in various parts of the world!
Of going in Ships

Many will forsake their own dwellings and carry with them all their belongings and will go to live in other parts.
Of moving on All Saints' Day k

Leonardo's Riddles

*H*ow many will they be who will bewail their deceased forefathers, carrying lights to them.
Of All Souls' Day [l]

*I*nvisible money will procure the triumph of many who will spend it.
Of Friars, who spending nothing but words, receive great gifts and bestow Paradise

*M*any will there be who will die a painful death by means of the horns of cattle.
Of Bows made of the Horns of Oxen

*M*en will speak with each other from the most remote countries, and reply.
Of writing Letters from one Country to another

*M*en standing in opposite hemispheres will converse and deride each other and embrace each other, and understand each other's language.
Of Hemispheres, which are infinite; and which are divided by an infinite number of Lines, so that every Man always has one of these Lines between his Feet [m]

*T*here will be many men who, when they go to their labour will put on the richest clothes, and these will be made after the fashion of aprons.
Of Priests who say Mass

*A*nd unhappy women will, of their own free will, reveal to men all their sins and shameful and most secret deeds.
Of Friars who are Confessors

[k,l] All Saints' Day, or the Feast of All Saints, is observed on November 1. As the name suggests, it honors all of the saints and martyrs in the Catholic Church. All Souls' Day is observed on November 2, the day after the Feast of All Saints. The souls of the departed are honored with prayers, requiem masses and (as Leonardo implies) candlelit vigils.

[m] Leonardo's metaphor of everyone being connected to everyone else through meridians of longitude and parallels of latitude seems to come from his interest in problems of mapping. Among his many projects was finding a means by which to map the globe on a flat surface.

*M*any will there be who will give up work and labour and poverty of life and goods, and will go to live among wealth in splendid buildings, declaring that this is the way to make themselves acceptable to God.
Of Churches and the Habitations of Friars

*A*n infinite number of men will sell publicly and unhindered things of the very highest price, without leave from the Master of it; while it never was theirs nor in their power; and human justice will not prevent it.
Of Selling Paradise

*T*he simple folks will carry vast quantities of lights to light up the road for those who have entirely lost the power of sight.
Of the Dead which are carried to be buried

*A*nd whereas, at first, maidens could not be protected against the violence of Men, neither by the watchfulness of parents nor by strong walls, the time will come when the fathers and parents of those girls will pay a large price to a man who wants to marry them, even if they are rich, noble and most handsome. Certainly this seems as though nature wished to eradicate the human race as being useless to the world, and as spoiling all created things.
Of Dowries for Maidens

*T*here will be many which will increase in their destruction.
The Ball of Snow rolling over Snow

*T*here will be many who, forgetting their existence and their name, will lie as dead on the spoils of other dead creatures.
Sleeping on the Feathers of Birds

Leonardo's Riddles

The solar rays will kindle fire on the earth, by which a thing that is under the sky will be set on fire, and, being reflected by some obstacle, it will bend downwards.

The Concave Mirror kindles a Fire, with which we heat the oven, and this has its foundation beneath its roof

Those who give light for divine service will be destroyed.

The Bees which make the Wax for Candles

Dead things will come from underground and by their fierce movements will send numberless human beings out of the world.

Iron, which comes from under ground, is dead but the Weapons are made of it which kill so many Men

Men will cast away their own victuals.

That is, in Sowing

Feathers will raise men, as they do birds, towards heaven.

That is, by the Letters which are written with Quills

The works of men's hands will occasion their death.

Swords and Spears

Men out of fear will cling to the thing they most fear.

That is, they will be miserable lest they should fall into Misery

Things that are separate shall be united and acquire such virtue that they will restore to man his lost memory.

That is, Papyrus sheets, which are made of separate strips and have preserved the memory of the things and acts of men

*T*he bones of the Dead will be seen to govern the fortunes of him who moves them.

By Dice

*C*attle with their horns protect the Flame from its death.

In a Lantern

*T*he Forests will bring forth young which will be the cause of their death.

The handle of the Hatchet

*M*en will deal bitter blows to that which is the cause of their life.

In threshing Grain

*T*he skins of animals will rouse men from their silence with great outcries and curses.

Balls for playing Games

*V*ery often a thing that is itself broken is the occasion of much union.

That is, the Comb made of split Cane which unites the threads of Silk

*T*he wind passing through the skins of animals will make men dance.

That is, the Bag-pipe, which makes people dance

*T*he more you converse with skins covered with sentiments, the more wisdom will you acquire.

Of the Skins of Animals which have the sense of feeling what is in the things written

*M*en will come into so wretched a plight that they will be glad that others will derive profit from their sufferings or from the loss of their real wealth, that is health.

Of Physicians, who live by sickness

Leonardo's Riddles

*T*hose who are dead will, after a thousand years be those who will give a livelihood to many who are living.

Of the Religion of Friars, who live by the Saints who have been dead a great while

*H*uge figures will appear in human shape, and the nearer you get to them, the more will their immense size diminish.

Of the Shadow cast by a man at night with a light

*F*athers and mothers will be seen to take much more delight in their step-children than in their own children.

Of Trees, which nourish grafted shoots

*O*ut of cavernous pits a thing shall come forth which will make all the nations of the world toil and sweat with the greatest torments, anxiety and labour, that they may gain its aid.

Money and Gold

*T*he malicious and terrible monster will cause so much terror of itself in men that they will rush together, with a rapid motion, like madmen, thinking they are escaping her boundless force.

Of the Dread of Poverty

*T*he man who may be most necessary to him who needs him, will be repaid with ingratitude, that is greatly contemned.

Of Advice

*T*he East will be seen to rush to the West and the South to the North in confusion round and about the universe, with great noise and trembling or fury.

In the East wind which rushes to the West

A great part of the sea will fly towards heaven and for a long time will not return.

That is, in Clouds

Animals will be seen on the earth who will always be fighting against each other with the greatest loss and frequent deaths on each side. And there will be no end to their malignity; by their strong limbs we shall see a great portion of the trees of the vast forests laid low throughout the universe; and, when they are filled with food the satisfaction of their desires will be to deal death and grief and labour and wars and fury to every living thing; and from their immoderate pride they will desire to rise towards heaven, but the too great weight of their limbs will keep them down. Nothing will remain on earth, or under the earth or in the waters which will not be persecuted, disturbed and spoiled, and those of one country removed into another. And their bodies will become the sepulture and means of transit of all they have killed.

 O Earth! why dost thou not open and engulf them in the fissures of thy vast abyss and caverns, and no longer display in the sight of heaven such a cruel and horrible monster.
Of the Cruelty of Man

The greatest mountains, even those which are remote from the sea shore, will drive the sea from its place.
This is, by Rivers which carry the Earth they wash away from the Mountains and bear it to the Sea-shore; and where the Earth comes the sea must retire

The water dropped from the clouds still in motion on the flanks of mountains will lie still for a long period of time without any motion whatever; and this will happen in many and divers lands.
Snow, which falls in flakes and is Water

The waters of the sea will rise above the high peaks of the mountains towards heaven and fall again on to the dwellings of men.
That is, in Cloud

An Abundance
of Invention

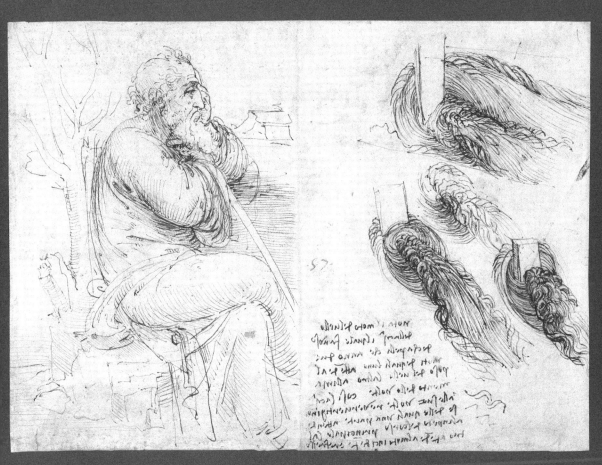

Afterword

Afterword

The Leonardo whom we discover in these pages does not, perhaps inevitably, reveal the same genius of the Leonardo we encounter in paintings such as the *Last Supper* or the *Mona Lisa*. These paintings were labors of love that took years of concentrated effort. Nor do the fables and stories disclose the same effort and ingenuity as his writings on, say, anatomy or mechanics. They show us, however, a Leonardo with whom were are less familiar—a more human and intimate Leonardo, who could laugh and joke and despair. They give us, in a sense, the "table talk" of one of history's great geniuses—the Leonardo that his friends would have known in his moments of relaxation.

Though largely unfinished and not always entirely successful or original, these writings were no dry exercise for Leonardo. His obvious joy in telling stories or recording arcane details about mythological creatures suggests that these efforts were sources of great pleasure to him as he worked on his larger commissions. Indeed, many of them were written in the early 1490s, when he was working on the Sforza Horse (a giant bronze equestrian statue) and about to embark on the *Last Supper*—two projects that were time-consuming and both intellectually and physically taxing. In these stories and riddles, Leonardo undoubtedly diverted himself every bit as much as he entertained the restless courtiers in Milan.

And we, too, are entertained. The fables, riddles and bestiary leave us, finally, with the glimpse we get of Leonardo in Verrocchio's workshop, at the start of his marvelous career: the curly-headed youth with the knowing smile, his mind teeming with an abundance of invention.

Works Cited

Ady, Cecilia M. *A History of Milan under the Sforza*. London: Methuen, 1907.

Boccaccio, Giovanni. *The Decameron*. Trans. Guido Waldman. Oxford: Oxford University Press, 1993.

Clark, Kenneth. *Leonardo da Vinci*. Rev. ed. Harmondsworth, Middlesex: Penguin, 1989.

Cottegnies, Lines. "The Art of Schooling Mankind: The Uses of Fable in Roger L'Estrange's *Aesop's Fables* (1692)." In *Roger L'Estrange and the Making of Restoration Culture*. Anne Dunan-Page and Beth Lynch, eds. Aldershot, Hants.: Ashgate, 2008.

Dante. *The Inferno*. Ed. and trans. Mark Musa. Bloomington: Indiana University Press, 1995.

Kemp, Martin. *Leonardo da Vinci: The Marvellous Works of Nature and Man*. Rev. ed. Oxford: Oxford University Press, 2006.

Lomazzo, Gian Paolo. *Trattato dell'Arte della Pittura, Scultura et Architettura*. Milan: 1584.

Machiavelli, Niccolò. *The Prince*. Trans. George Bull. London: Penguin, 2003.

Richter, Jean Paul, ed. *The Literary Works of Leonardo da Vinci*. London: Sampson Low, Marston, Searle & Rivington, 1883.

Vasari, Giorgio. *Lives of the Artists*. Trans. George Bull. vol. 1. Harmondsworth, Middlesex: Penguin, 1987.

Acknowledgments

My thanks go, first of all, to my editor at the Levenger Press, Mim Harrison, for giving me the opportunity to work on this project—and for her patience, her good humor and her wise suggestions for how to make things better. I'm also deeply grateful to the founders of the Levenger Press, Steve and Lori Leveen, friends of readers and writers everywhere.

I also owe thanks to three friends and fellow writers who kindly looked at, and offered valuable comments on, a draft version of the manuscript: Nancy Goldstone, Larry Goldstone and Michael Sims. And I am grateful, as always, to another fellow writer: my wife, Melanie.

Finally, I dedicate this book to my longtime editor and publisher, George Gibson, and his wife, Linda: good friends, generous hosts, and kind souls.

About the Author

Ross King is a leading scholar of Italian Renaissance art and architecture and a bestselling author of books on these subjects as well as French Impressionism. His *Michelangelo and the Pope's Ceiling* was a National Book Critics Circle Award nominee, and *Brunelleschi's Dome* was named the 2001 BookSense Nonfiction Book of the Year. He is also the author of *The Judgment of Paris* and *Machiavelli: Philosopher of Power.*

Ross has lectured widely in the United States, his native Canada and Europe, where he has conducted tours of the Sistine Chapel in the Vatican. He lives in England, outside of Oxford, with his wife, Melanie.

In addition to *The Fantasia of Leonardo da Vinci,* Ross is completing a history of Leonardo and his painting the *Last Supper* that will be published by Walker & Company in 2012.

Uncommon Books for Serious Readers

Levenger Press is the publishing arm of

LEVENGER®

Levengerpress.com 800.544.0880

To write your review of this book or any Levenger Press title,
please visit Levenger.com and type the book title into the Search box.